IMAGES
of America

EARLY AMUSEMENT PARKS
OF ORANGE COUNTY

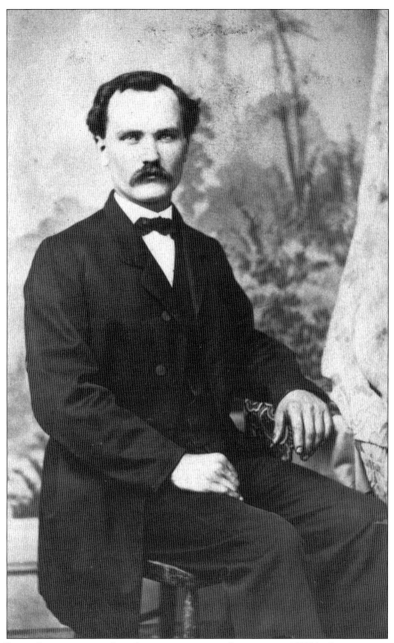

Frederich Conrad experimented in the entertainment business in 1875 by buying an acre of land on Lincoln Avenue near Manchester Avenue in Anaheim and building Tivoli Gardens. This was a miniature imitation of the world-famous amusement park in Denmark. The Anaheim theme park—which featured a dance hall, bowling alley, and croquet court—was short-lived. Please see the introduction for details on Conrad. (Courtesy of Anaheim Public Library.)

ON THE COVER: This merry-go-round dates back to 1896 and was built by Tom Dentzel of Dentzel Carousel Company in Pennsylvania Dutch Country. It operated for 22 years at Hershey Park in Hershey, Pennsylvania, before going into storage until it was purchased by Bud Hurlbut and placed at Knott's Berry Farm.

IMAGES
of America

EARLY AMUSEMENT PARKS
OF ORANGE COUNTY

Richard Harris

ARCADIA
PUBLISHING

Published by Arcadia Publishing
Charleston SC, Chicago IL, Portsmouth NH, San Francisco CA

Printed in the United States of America

Library of Congress Catalog Card Number: 2008922711

For all general information contact Arcadia Publishing at:
Telephone 843-853-2070
Fax 843-853-0044
E-mail sales@arcadiapublishing.com
For customer service and orders:
Toll-Free 1-888-313-2665

Visit us on the Internet at www.arcadiapublishing.com

This book is dedicated to my wife, Christine, and my three children—Matthew, Stephanie, and Lindsay—as well as to my mentor and the creator of the Log Ride and the Mine Ride, Bud Hurlbut, and to Harry Suker for telling me his marvelous stories.

CONTENTS

ACKNOWLEDGMENTS

I would like to thank the following people who made this book possible by contributing their information and pictures: Newport Harbor Nautical Museum, Jay Jennings, Steve Knott, Orange County Archives, Gary Winn, Harrison "Buzz" Price, Long Beach *Press-Telegram*, Steve DeGaetano, Michael Broggie, Bud Hurlbut, Harry Suker, Dan Brucker, Ilene Roth, Dave Oneal, and the Mission Viejo Heritage Committee. The support of these people and organizations helped enhance the information within these pages. The photographs in this book were from the author's private collection or were donated by the credited parties.

INTRODUCTION

"Amusement park" is a term meaning a collection of amusement rides and attractions assembled for entertaining a large group of people. An amusement park is more than just a city park or playground. An amusement park can be permanent or temporary. It can be periodic, setting up in a town for as little as a few days or a few weeks per year. The temporary or often annual amusement park is usually a traveling show with mobile rides and easily transported booths. It is also called a funfair or carnival.

Original amusement parks were the historical precursors to the modern theme parks as well as the more traditional midway arcades and rides that are set up at county and state fairs in the United States. Amusement parks have largely been replaced by theme parks, and the two terms are often used interchangeably. For example, a European amusement/theme park dating from 1583 and operating to this day is called Bakken in Klampenborg, Sjælland Denmark.

The first American amusement park, in the modern sense, was the 1893 Columbian Exposition in Chicago, Illinois. Also known as the World's Fair, the Columbian Exposition was so financially successful that by October, attendance had reached more than 6.8 million paid visitors. The 1893 World's Fair was the first to have a Ferris wheel and an arcade midway, as well as various concessions.

The exposition as a whole made more than $1 million in surplus funds that were returned to its 30,000 stockholders. No exposition in the 19th century could boast such a success, and the World's Columbian Exposition became the standard by which all fairs in the following decades were measured.

This conglomeration of attractions was the template used to create amusement parks for the next half-century, including those known as trolley parks. The rise of trolley parks began when Charles J. Van Depoele created an under-running trolley pole that could power an electric trolley.

Trolley companies were charged a flat rate for their electricity, regardless of how much power was actually used. With most transportation occurring during the workweek, the trolley companies wanted to induce people to travel on the weekends. There were more than 1,000 of these trolley parks in the United States prior to the Great Depression following the 1929 Wall Street stock market crash. Some were simply a picnic grove with an athletic field and swimming area. Others were amusement parks with a variety of rides and games as well as dance halls and roller-skating rinks.

The theme park is the modern amusement park, either based on a central motif or divided into several themed areas. Large resorts, such as Walt Disney World in Orlando, Florida, actually house several different theme parks within one area.

The first park built that is still in operation to this day is the 1583-vintage aforementioned Bakken, located north of Copenhagen, Denmark. The oldest operating amusement park in the United States is Lake Compounce in Bristol, Connecticut, which opened for business in 1846.

Other important developments in early theme park history largely occurred in Southern California. Knott's Berry Farm, located in Buena Park, originally was a productive berry farm.

Walt Disney is credited with having originated the concept of the themed amusement park. Disneyland in Anaheim, Orange County, was based loosely on Tivoli Gardens in Copenhagen, Denmark. The park's Sleeping Beauty Castle, an icon of Disneyland and the entrance to Fantasyland, was reputedly replicated from Schloss Neuschwanstein, a castle in the southern state of Bavaria in Germany built in 1869 by Ludwig II, King of Bavaria.

Several of the early Disneyland attractions included Great Moments with Mr. Lincoln, It's a Small World, and Primeval World, a dinosaur exhibit built by Walt Disney's in-house manufacturing department, Walt Disney Imagineering, for the 1964 New York World's Fair. When the fair closed, Disney relocated the show to a permanent home at Disneyland.

Disney took these influences and melded them with the popular Disney animated characters and his unique vision, and Disneyland was born. Disneyland, which thrived off the synergy created between its tourism and a nationally aired Sunday-night television show, officially opened in Anaheim on July 17, 1955, and changed the amusement industry forever.

Way before there was a Disneyland or a Knott's Berry Farm, the first amusement park located within the boundaries of today's Orange County was built in the 1870s by Frederich Conrad, a prominent Anaheim brewer and saloon owner. Before brewing beer, Conrad operated a brief venture in the entertainment business in 1875 when he bought an acre of land on the south side of Lincoln Avenue between the Southern Pacific railroad tracks and Manchester Avenue. What he built was a miniature Tivoli Gardens—a small imitation of the famous Tivoli Gardens in Copenhagen, Denmark. Anaheim's Tivoli Gardens opened in 1876, making it the first amusement park in Anaheim and Orange County.

Between Conrad's new brewery and the railroad tracks, he established a park by planting cypress and pine umbrella trees. He constructed a dozen or so summerhouses built of lath. Each one contained a table with benches, and many other tables and chairs were placed throughout the park. Conrad's attraction became a gathering place for people from miles around.

The entertainment complex eventually consisted of a bar, dancing pavilion, bowling alley, and shooting gallery. A croquet court was added, and often the establishment would hold singing competitions. Large groups would arrive from as far away as San Francisco, disembarking at the Anaheim train depot. Frederich Conrad sold his version of Tivoli Gardens in 1921 to the Anaheim Concordia Club, and the name was changed to Columbia Gardens.

One

COASTAL
AMUSEMENT PARKS

In 1906, Fred Lewis owned a tract of land on the waterfront in old Balboa, which is a portion of today's city of Newport Beach. For years, he operated a boatyard, storing and repainting boats for the locals. In 1935, Al Anderson bought the old boatyard, located next to the Balboa Island Ferry Landing, with the intention of constructing an attraction of rides and game.

The original Balboa Fun Zone opened in 1936 and was run by families, much like it is today. Anderson was known for his alleged love of gambling. During World War II, secret poker games were supposedly conducted in his upstairs apartment on the Fun Zone grounds. Anderson owned some of the Fun Zone's signature rides, such as the carousel and a Ferris wheel. Other nearby families set up more attractions as the years went by, such as the boats, bumper cars, and the arcades.

Al Anderson owned the Fun Zone until 1972, when a lawsuit over a diving accident on one of the Fun Zone's less remembered attractions, the diving platform, forced him to close down because of foreclosure. Carl C. Hillgren of Newport Beach bought the Fun Zone and began a new chapter.

Philip A. Stanton set out to transform his new city of Seal Beach into "The Coney Island of the Pacific." The city is located where Orange and Los Angeles Counties meet on the Pacific Ocean's shores. The Joy Zone started out as a beachside amusement center in 1916. The original pier, which was erected in 1906, ended up being a part of the Joy Zone. With so many people showing up at the Joy Zone, the city required a wider pier and installed one in 1915. The new wooden structure was advertised as the longest pier south of San Francisco.

The wooden roller coaster known as the Derby was originally built for an exposition in San Francisco. It was dismantled, moved, and then reassembled in Seal Beach, giving the Joy Zone a speedy ride. The Joy Zone billed itself as the "playground of Southern California."

A structure at the pier's foot served as a bathhouse, and the second story held Frank Burt's Jewel City Café. The Joy Zone, which attracted as many as 20,000 people a week, saw patronage decline during the Great Depression. The roller coaster eventually burned down.

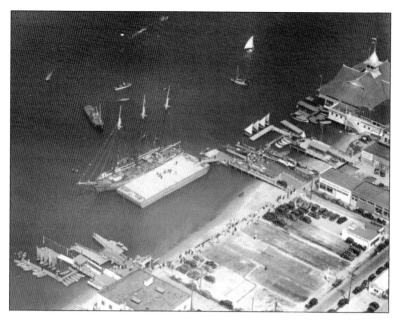

This aerial view depicts the Fun Zone's location in Balboa. The amusement park opened in 1906. Fred Lewis owned a tract of land on the waterfront in old Balboa and for decades operated his boatyard there, storing and repainting boats for the locals. (Courtesy of Newport Harbor Nautical Museum.)

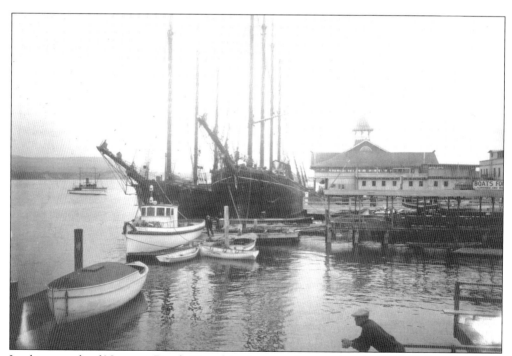

Looking north of Newport Beach Pier, this photograph was taken in 1940. Balboa Fun Zone became an attraction that beckoned kids of all ages from near and far. If a person were going to Newport, he or she went to the Fun Zone. And any kids who lived anywhere nearby wanted to work there. (Courtesy of Newport Harbor Nautical Museum.)

Al Anderson purchased this Ferris wheel in 1936 to add to his Fun Zone. The 45-foot wheel was bought from a Seattle company. (Courtesy of Gary Winn.)

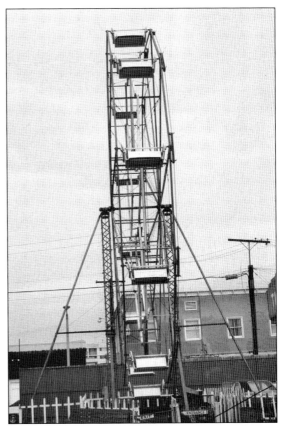

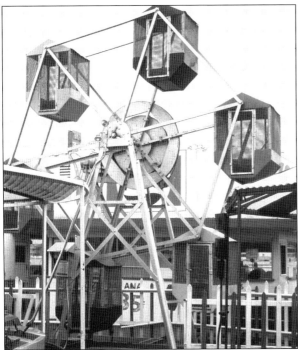

The Bird Cage Ferris wheel was added later to the Fun Zone after Al Anderson sold it to Harold Hannaford, who owned and operated some of the remaining kiddy rides—the boats, cars, Bird Cage Ferris wheel, and the arcade zone that housed such fondly remembered favorites as Punk Rack and Spill the Milk. (Courtesy of Gary Winn.)

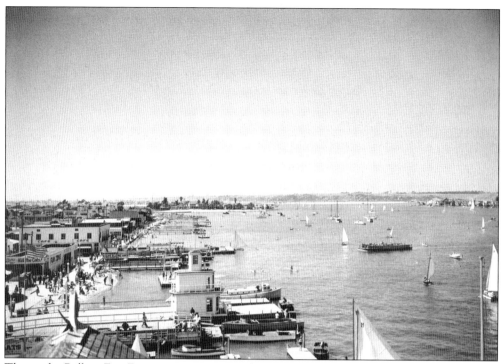

This is the Balboa Fun Zone as it was seen in the 1960s. Al Anderson's ownership of the zone ended in 1972. (Courtesy Newport Harbor Nautical Museum.)

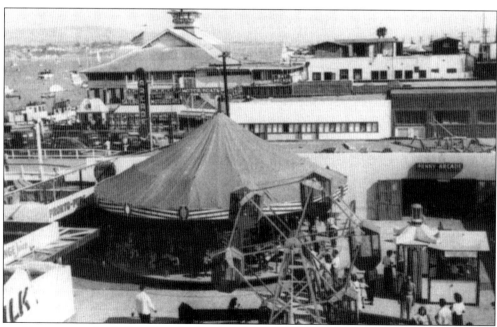

Looking east on the Balboa Boardwalk, this photograph shows the Bird Cage Ferris wheel, in the lower portion of photograph, in the 1960s.

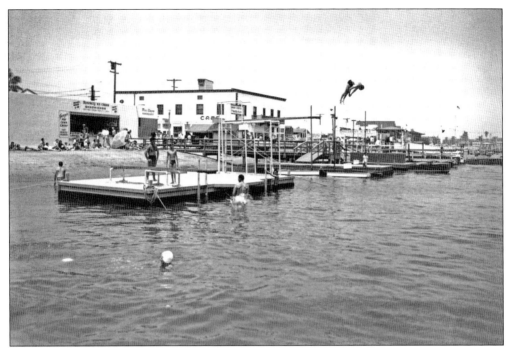

Al Anderson lost the property when someone on one of the Fun Zone's less remembered attractions, the diving platform, got hurt and filed a lawsuit. Anderson had no insurance to defend himself, and he lost the Fun Zone through foreclosure. (Courtesy Newport Harbor Nautical Museum.)

Early on, the area that is now the southern portion of Seal Beach was known as Anaheim Landing, consisting of a boat dock and seaside recreation area named after the nearby town of Anaheim. Anaheim Bay was adjacent to it, just to the south. Seal Beach is the most northerly coastal city in Orange County. (Courtesy of the Seal Beach Public Library.)

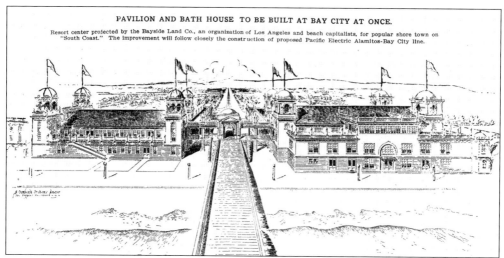

This artist's rendering appeared in a local newspaper announcing that a pavilion and bathhouse were to be built at Bay City. This was to be a resort center constructed by the Bayside Land Company. The improvement was expected to be erected on the shoreline where the Alamitos–Bay City Line of the Pacific Electric (PE) connected to the coastal PE Red Car line. (Courtesy of the Seal Beach Public Library.)

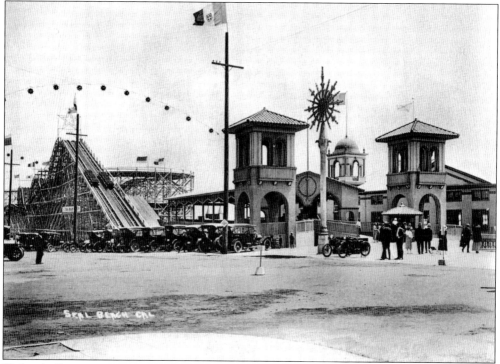

Philip A. Stanton set out to transform the future Seal Beach into the "Coney Island of the Pacific." The Joy Zone was started as an amusement center in 1916. Frank Burt moved to Seal Beach to form Jewel City Amusement Company and built the Jewel City Café. (Courtesy of First American Title.)

14

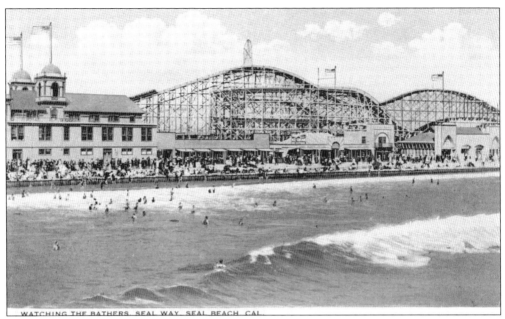

This view from a 1917 postcard looks out onto the Joy Zone, containing the Derby roller coaster and the bathhouse in the background. The size of the renowned Derby can be gauged in this view. (Courtesy of First American Title.)

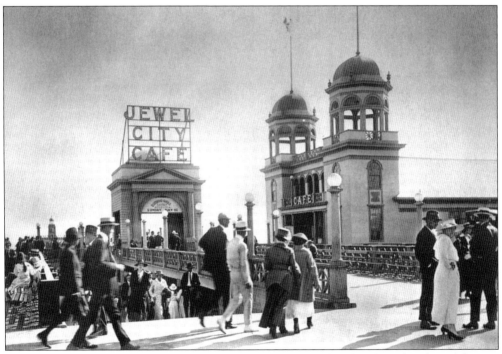

The famed Jewel City Café sign advertises the Seal Beach landmark café in this shot of the pier looking westward out onto the Pacific Ocean. (Courtesy of First American Title.)

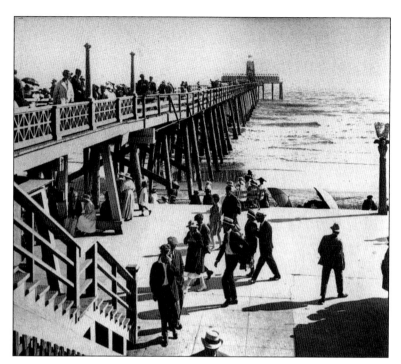

The wooden supports of the pier at the Joy Zone can be seen here on a busy afternoon. Many of the old wooden piers in Southern California coastal communities were replaced in the early part of the 20th century by reinforced concrete piers. (Courtesy of First American Title.)

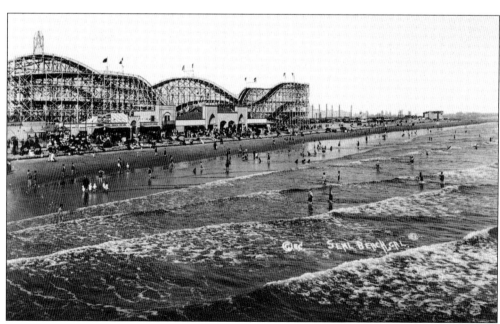

The tracks of the Derby are visible in this shot of the Joy Zone, which was one of the Southern California coast's most famous attractions. The Derby was originally erected in San Francisco and was brought south and rebuilt at the Joy Zone. (Courtesy of First American Title.)

Two

KNOTT'S BERRY FARM

The year was 1920 when Walter and Cordelia Knott moved to the then-sleepy community of Buena Park, California, to farm 20 acres of rented land. Today that land is part of the 160-acre Knott's Berry Farm, America's first theme park and, in the 21st century, the 12th most-visited amusement park in the country.

It was not until the 1930s that Walter became associated with the "boysenberry," which would become the family trademark. Nearby, Anaheim parks superintendent Rudolph Boysen had experimented with a new strain of berry. But the plants kept dying on the vine. Walter took the scraggly plants, nurtured them to health and named the new berry—actually a cross between a loganberry, a red raspberry, and a blackberry—after its originator.

Cordelia began selling jams and jellies made from Walter's berries. In 1934, Cordelia Knott began using her wedding china to serve visitors her home-cooked chicken dinners for 65¢ each. With the immediate success of the chicken dinners, the berry farm's fame grew, and by 1940, the restaurant was serving as many as 4,000 dinners on Sunday evenings.

Walter Knott wanted to give his waiting customers something to do and also wanted to pay homage to the pioneering spirit of his grandparents and his love of the Old West. So Walter Knott developed Ghost Town, and eventually it came to be the first of Knott's Berry Farm's six themed areas.

Knott's Berry Farm had become famous for its "peek-ins," one of which was the talking inmate, Sad Eye Joe. Highlights of berry farm trips were pictures taken with the varmints, Handsome Brady and Whiskey Pete.

In the 1960s, the Calico Mine Ride was added to Knott's Berry Farm. The Calico Mine Ride took trips into the depths of an Old West mine, the "Calico Glory Hole!" as it was known. It opened in 1960 to rave reviews and used special effects, setting a new standard for the future of Knott's attractions.

The Timber Mountain Log Ride opened on July 11, 1969, and remains one of the top attractions at Knott's Berry Farm into the 21st century, having carried more than 150 million guests.

Fiesta Village was the second themed area in the amusement park, also debuting in 1969. Constructed under the supervision of Marion Knott, the daughter of the founders, it is a tribute to California's early Spanish heritage.

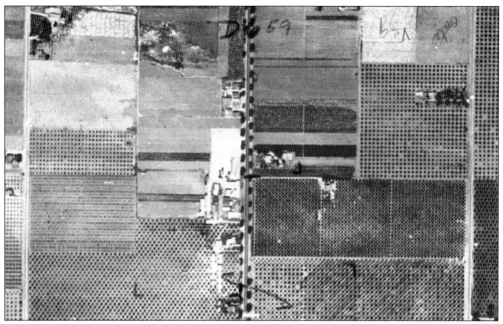

Walter Knott began farming in 1920 on rented land in Buena Park with his cousin, Jim Preston. This aerial view of Knott's Berry Farm depicts it in 1938. (Courtesy of the Orange County Archives.)

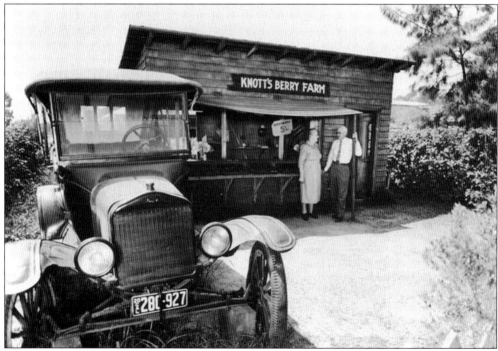

Walter and Cordelia Knott are shown at their roadside berry stand, beginning their operations around 1922. Cordelia sold jams and jellies made from Walter's berries. (Courtesy of the Orange County Archives.)

Cordelia Knott used her wedding china to serve visitors her home-cooked chicken dinners for 65¢ each. The success of the chicken dinners was immediate, and by 1940, the restaurant was serving as many as 4,000 dinners on Sunday evenings. (Courtesy of the Orange County Archives.)

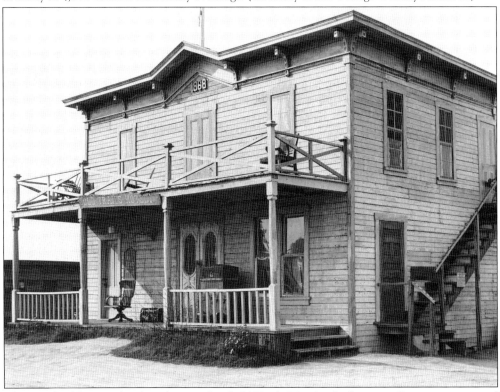

The first building Walter bought was the Gold Trails Hotel, which originally was constructed in Prescott, Arizona, in 1868. Adhering to authenticity, Walter brought in other buildings from deserted ghost towns, and Knott's Ghost Town as it exists today began to emerge. (Courtesy of the Orange County Archives.)

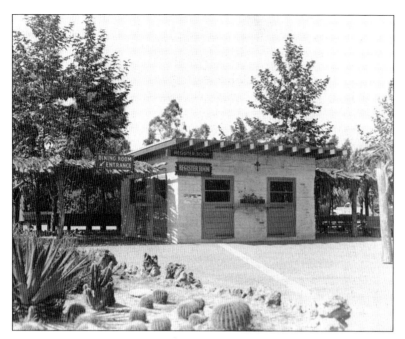

This is the registration room used to chart the guests for Knott's Berry Farm's Chicken Dinner Restaurant and steak meals. This photograph was taken in the 1940s. (Courtesy of the Orange County Archives.)

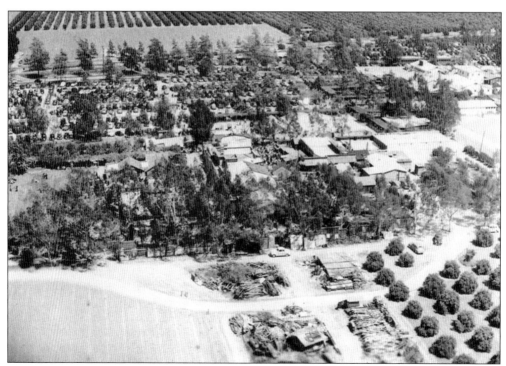

An aerial view of Knott's Berry Farm is seen on this mid-century postcard. In the upper center of the postcard is the horse arena. (Courtesy of the Orange County Archives.)

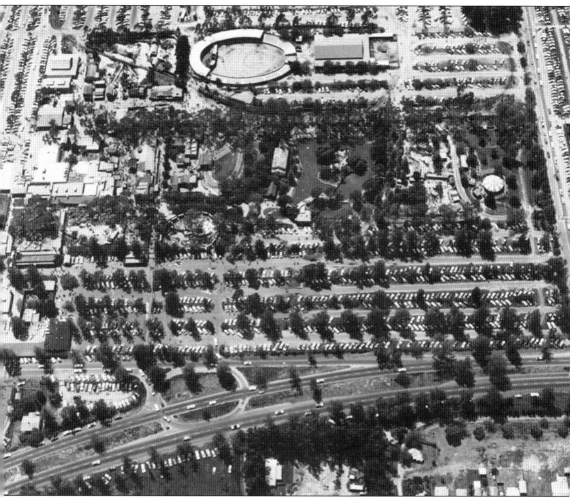

Another early aerial view of Knott's Berry Farm shows the horse arena in the center portion of the postcard. The Calico Mine Ride now occupies that space. This photograph was taken in 1953.

Handmade adobe bricks were used for the Steak House, Ghost Town Firehouse, and El Camino Real Arches at Knott's Berry Farm. These bricks were made from clay, straw, and horse manure. This photograph was taken in 1946. (Courtesy of the Orange County Archives.)

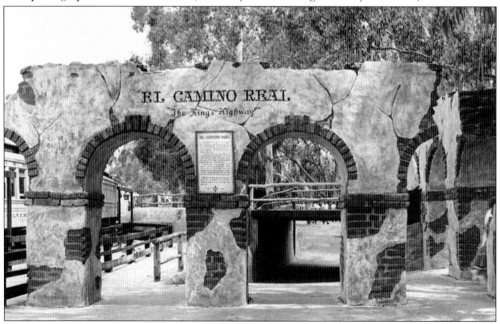

Knott's Berry Farm's El Camino Real Arches are depicted here, leading to Fiesta Village, the Church of Reflections, and the Chapel by the Lake. (Courtesy of the Orange County Archives.)

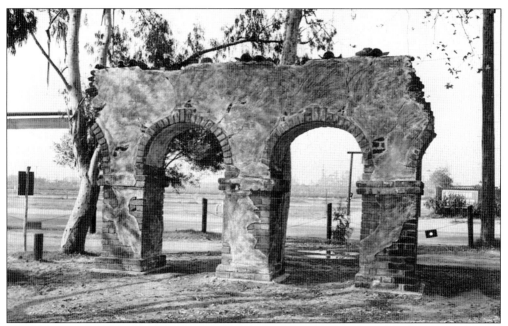

The El Camino Real Arches are also seen here leading to La Palma Avenue in Buena Park, with the California Alligator Farm in the background. (Courtesy of the Orange County Archives.)

Another view of the El Camino Real Arches is depicted here in Walter Knott's Ghost Town.

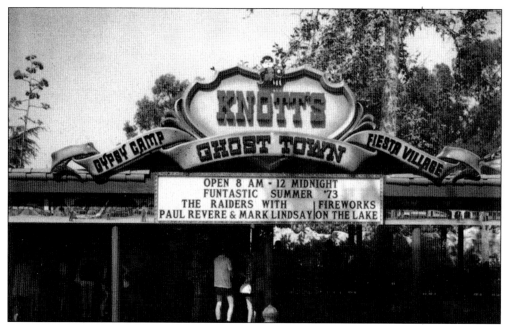

Knott's Berry Farm became fenced in 1968, and admission was charged to enter the amusement park: $1 for adults and 25¢ for kids. Knott's Berry Farm had developed from a roadside stand to a restaurant to, officially, an amusement park. Knott's was truly "America's First Theme Park." This photograph dates to 1973. (Courtesy of the Orange County Archives.)

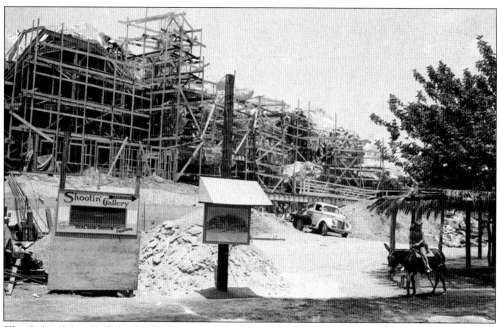

The Calico Mine Ride building was constructed at a cost of $3.5 million in 1960 dollars. By today's standards, it would cost more than $20 million, not including the trains and cars or the cost of the mannequins or other paraphernalia. (Courtesy of the Orange County Archives.)

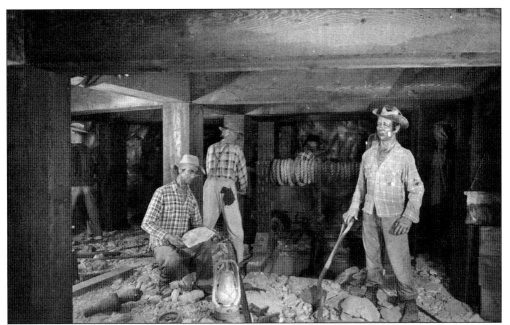

In the 1960s, the Calico Mine Ride was added to Knott's Berry Farm. The ride would take foreboding-seeming trips into the depths of an Old West mine. (Courtesy of the Orange County Archives.)

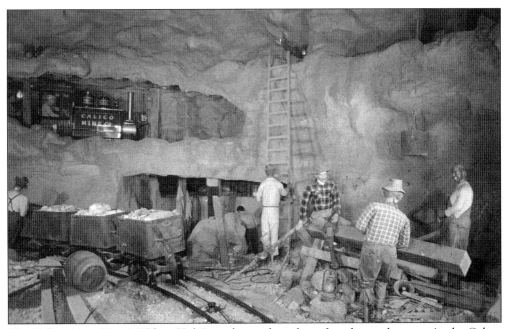

The Calico Mine Train's "Glory Hole" was larger than those found in real mines. As the Calico Mine Ride progresses, it returns to the glory hole area several times. The view from the top of the glory hole is an impressive sight to see. (Courtesy of the Orange County Archives.)

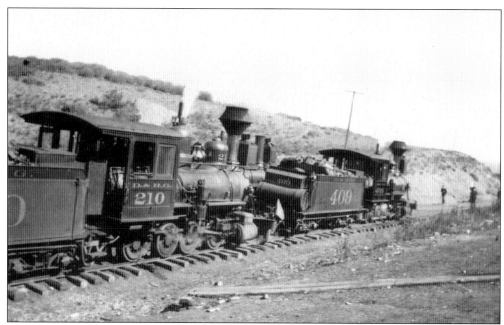

The Denver and Rio Grande narrow-gauge railroad, seen here in October 1906, near Montrose, Colorado, later went to Knott's Berry Farm. Walter Knott only bought some of the engines and rolling stock from the Rio Grande Southern because a lot of it went into historical repositories such as the Colorado Railroad Museum. (Courtesy of the Orange County Archives.)

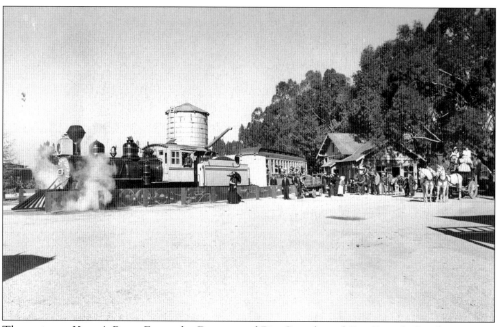

The trains at Knott's Berry Farm, the Denver and Rio Grande and Rio Grande Southern, trace their roots back to Colorado. The narrow gauge at Knott's Berry Farm is one built to a track gauge that was less than the standard gauge of 4 feet and 8.5 inches between the rails. (Courtesy of the Orange County Archives.)

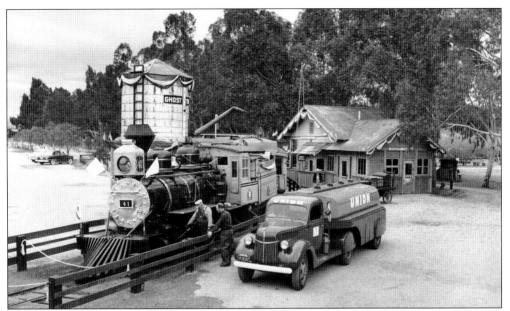

Walter Knott brought the equipment for the Ghost Town and Calico Railway to Buena Park in 1951 and completed it the following year. Locomotives No. 41 (formerly Rio Grande Southern 41, formerly of the Denver and Rio Grande No. 409 Red Cliff Line) and No. 340 (formerly Denver and Rio Grande No. 340, formerly Denver and Rio Grande No. 400 Green River Line) are both C-19s operating at Knott's. (Courtesy of the Orange County Archives.)

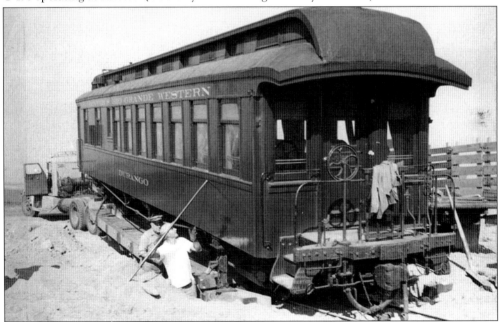

The parlor cars *Chama* and *Durango* were used by the president of the Rio Grande Southern, Otto Mears. Mears, a road builder, is given much credit for enabling development of the San Juan region of Colorado. Pictured here is the *Durango* on a flatbed railcar before being unloaded at Knott's Berry Farm. Durango, Colorado, and Chama, New Mexico, are communities in the Rocky Mountains. (Courtesy of the Orange County Archives.)

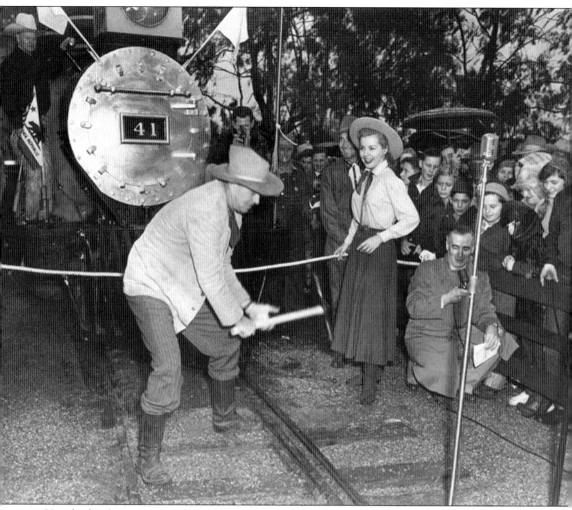

Hundreds of visitors attended the dedication of the new Ghost Town and Calico Railroad on January 12, 1952. Actor Sterling Hayden, who played McCabe in the movie *The Denver and Rio Grande* (1952), was on hand for the driving of the spike along with Kasey Rogers (also known as Laura Elliott), who played Linda in the movie. This event will be long remembered as a historic event at Knott's Berry Farm. (Courtesy of the Orange County Archives.)

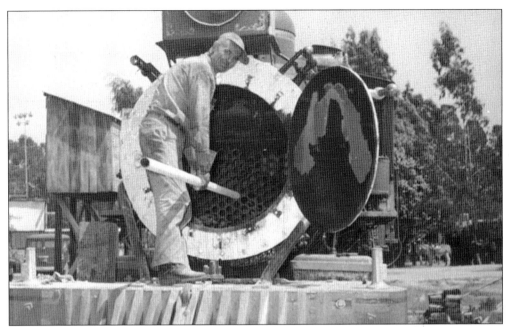

This is the Calico engine being restored by Ed Randow, standing here on the structure above the cowcatcher in 1954. (Courtesy of the Orange County Archives.)

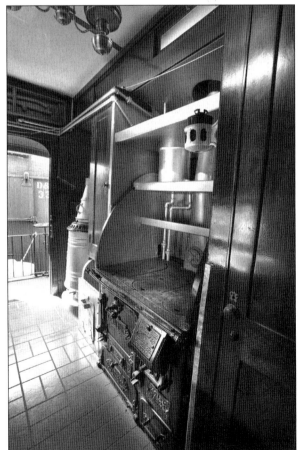

The interior of the kitchen in the president's private car of the Rio Grande Southern Railroad is seen here. The car was known as the *Edna*. (Courtesy of Steve Giuard and Richard Harris.)

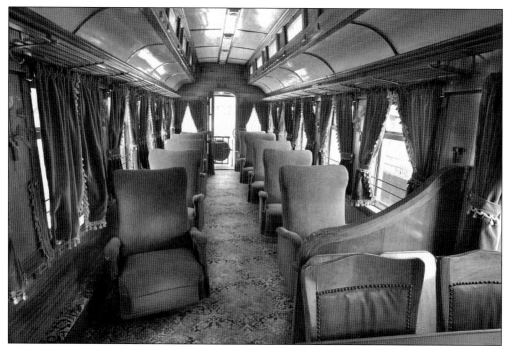

The *Durango* parlor car was used by the Knott family and invited guests for special events at Knott's Berry Farm. The entire interior is all original, outfitted with large plush seats and a carpeted floor. (Courtesy of Steve Giuard and Richard Harris.)

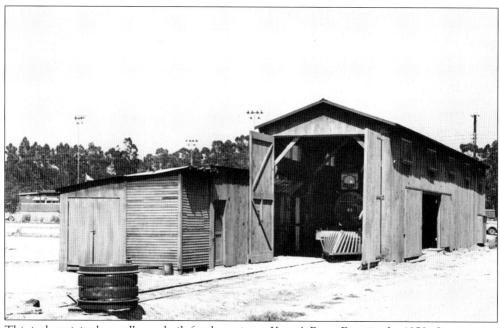

This is the original roundhouse built for the trains at Knott's Berry Farm in the 1950s. Locomotive No. 41 was actually built in 1881. (Courtesy of the Orange County Archives.)

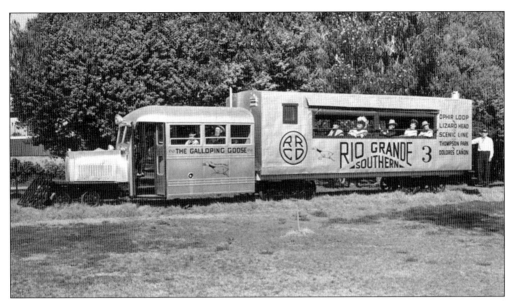

The No. 3 *Galloping Goose* was built in 1931, and Walter Knott bought it in 1952. The overhaul of the *Goose* was done under the direction of Ed Randow. The *Galloping Goose* was completely worked over from the cowcatcher to the rear platform. It was put in perfect working order before it was engaged for operation at Knott's Berry Farm. (Courtesy of the Orange County Archives.)

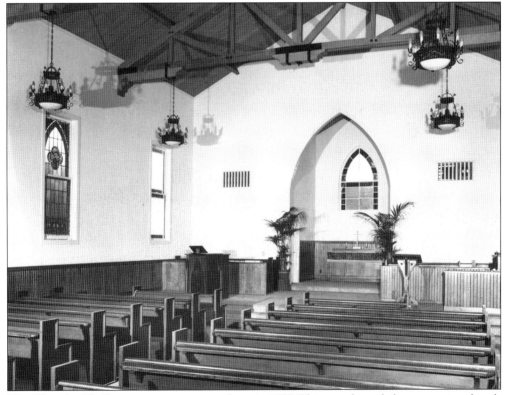

The Church of Reflections interior is seen here in 1955. This was the only known active church within an operating theme park. (Courtesy of the Orange County Archives.)

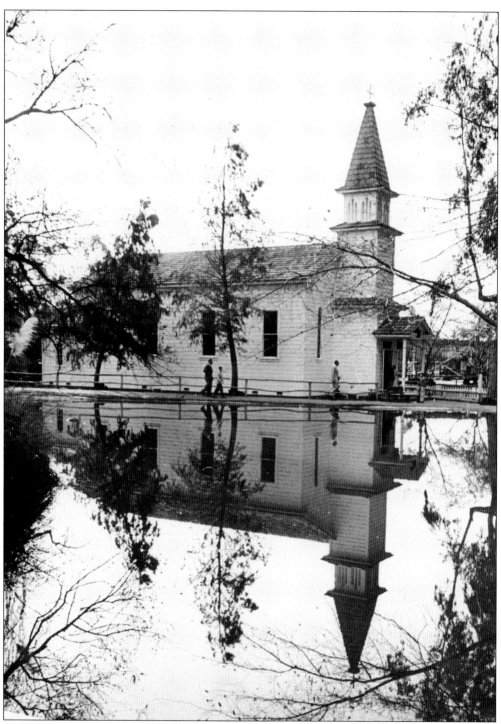

The Church of Reflections was built in Downey, Los Angeles County, in 1876 and was called Downey First Baptist Church before it was moved and rebuilt in 1955 at Knott's Berry Farm. The farm's worship center is a multidenominational church that was rescued from demolition by Walter Knott. (Courtesy of the Orange County Archives.)

Haunted Shack, the house of strange phenomena, opened in June 1954. Daily tours revealed the gravity-defying mysteries inside, as told by the voice of the wisecracking Slanty Sam in "The Legend of the Haunted Shack." The shack, which was relocated to Knott's Berry Farm from the ghost town of Calico, California, closed in September 2000 to make room for a new attraction. (Courtesy of the Orange County Archives.)

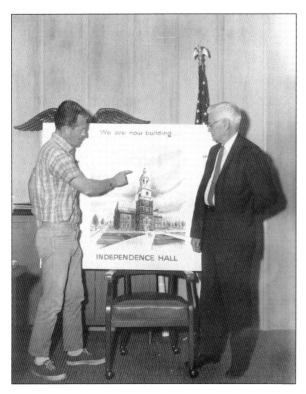

Walter Knott's dream was to build a replica of Independence Hall, the iconic national landmark in Philadelphia, Pennsylvania. The dream came alive on the Fourth of July in 1966. The building is so exact that one can even see fingerprints in the bricks, just like in the original in Philadelphia. Independence Hall is located adjacent to the main park area. (Courtesy of the Orange County Archives.)

The structure was so realistic that the Philadelphia Bicentennial Reconstruction Committee later borrowed Knott's building plans when it could not locate the original blueprints for Pennsylvania's historic landmark. (Courtesy of the Orange County Archives.)

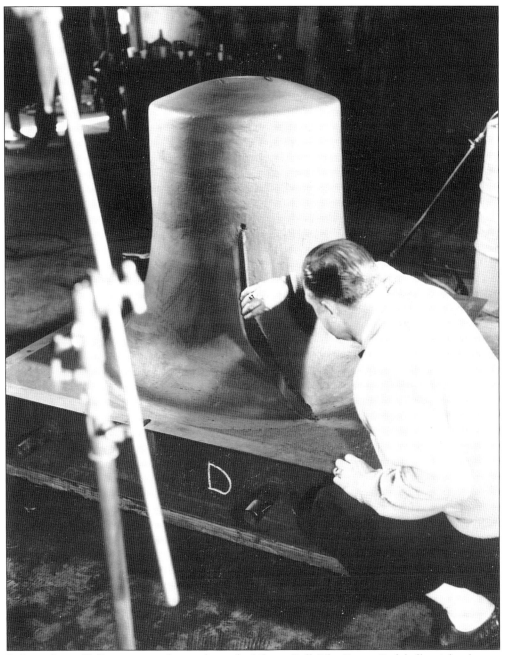

Independence Hall is not complete without the Liberty Bell. The Buena Park bell weighs about a short ton and change, 2,075 pounds in all, and only 5 pounds less than the Philadelphia original. Here Bud Hurlbut measures it to get ready to crack it. Two weeks of work was put into getting the crack exactly like the one marring the original. (Courtesy of the Orange County Archives.)

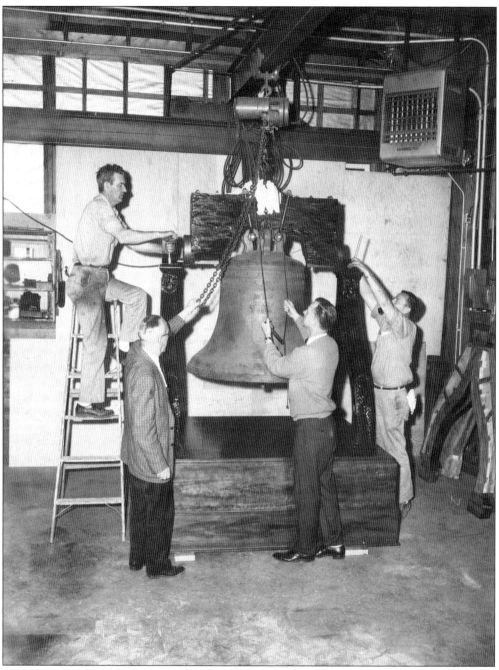

Here the Liberty Bell is being fitted for the yoke at the Hurlbut Amusement Company. Bud Hurlbut is pictured here second from the right, holding the chain, with the outfit's employees; Walter Knott is second to the left. (Courtesy of the Orange County Archives.)

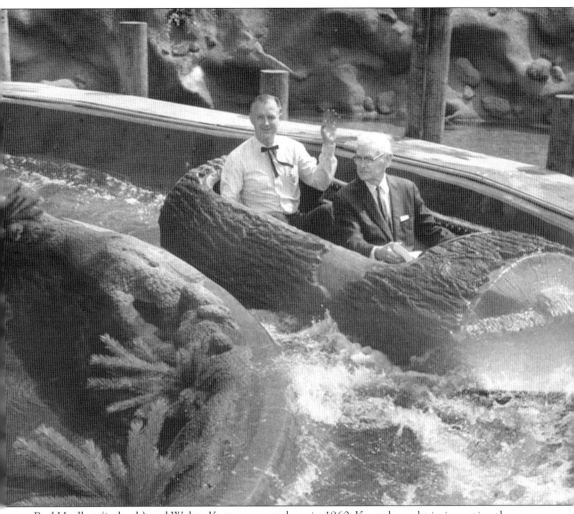

Bud Hurlbut (in back) and Walter Knott are seen here in 1960. Knott brought in inventive theme park–attraction designer Bud Hurlbut to build and operate various themed rides on Knott's Berry Farm property. One of those was the classic Calico Mine Ride; the second one was the Timber Mountain Log Ride. (Courtesy of the Orange County Archives.)

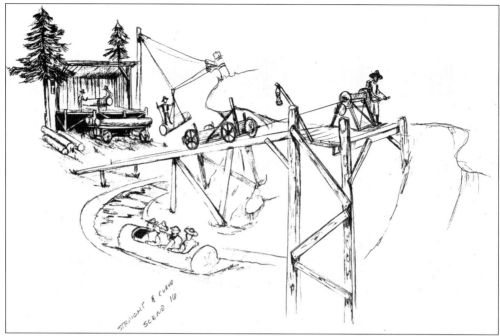

This artist's sketch of the Timber Mountain Log Ride depicts guests aboard a hollowed-out log for a journey deep into the 75-foot-high Timber Mountain. (Courtesy of the Orange County Archives.)

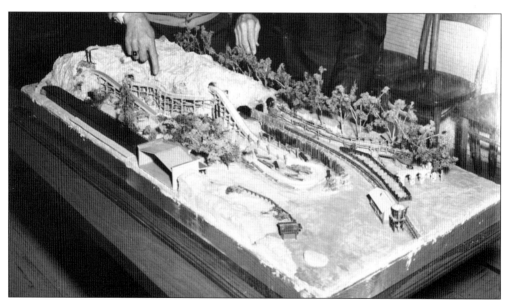

This small-scale replica of the Timber Mountain Log Ride helps illustrate the ride's revolutionary "free-float" movement, developed by Bud Hurlbut in 1969. The concept has since been copied at theme and amusement parks worldwide. The free-float movement enables the 450-pound logs to float freely down the 2,100-foot waterway, re-creating the loggers' practice of riding their logs back to camp after a hard day's worth of work. (Courtesy of the Orange County Archives.)

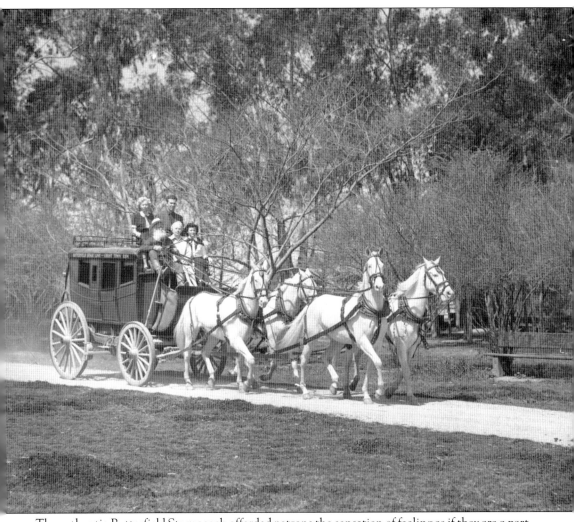

The authentic Butterfield Stagecoach afforded patrons the sensation of feeling as if they are a part of history. The Butterfield Stagecoach ride includes three original Butterfield coaches. (Courtesy of the Orange County Archives.)

The Overland Southern coach and the Knott's Berry Farm coach were built for the farm in 1954. (Courtesy of the Orange County Archives.)

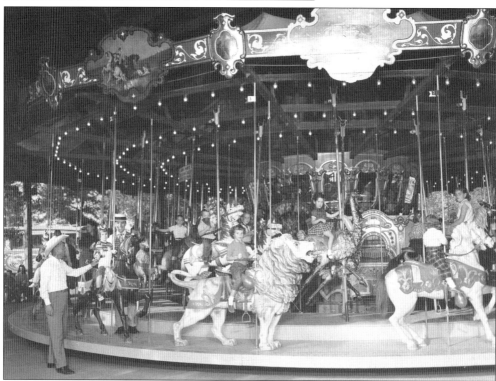

The merry-go-round dates to 1896 and was built by Tom Dentzel of the Dentzel Carousel Company in Pennsylvania Dutch Country. This merry-go-round was operated for 22 years at Hershey Park in Hershey, Pennsylvania. For around 19 years, its whereabouts were unknown. Then it operated again at Brady Park in Canton, Ohio, from 1936 to 1947. This merry-go-round stayed in storage until it was purchased by, and placed in, Knott's Berry Farm. (Courtesy of the Orange County Archives.)

Three

WALT DISNEY AND DISNEYLAND

"To all who come to this happy place: welcome," invited Walt Disney on opening day in 1955 of his new Anaheim theme park. "Disneyland is your land. Here age relives fond memories of the past . . . and here youth may savor the challenge and promise of the future. Disneyland is dedicated to the ideals, the dreams and the hard facts that have created America . . . with the hope that it will be a source of joy and inspiration to all the world."

Disneyland really began with Walt's two daughters, who were very young. Sundays were always "Daddy's Days" for Walt Disney, who watched them play from a park bench. He began thinking how he could create an attraction for kids as well as adults. Walt envisioned a small amusement park.

His plans for this amusement park date back as far as 1932, when he considered building an amusement park to house his cartoon characters on the back of his Burbank Studios lot. However, as Disney's activities expanded, so did his dream. It became apparent to him that he needed a large site.

When Walt was ready to go ahead with his project, he asked Roy O. Disney, his brother, to telephone Stanford Research Institute. Roy spoke to research economist Harrison "Buzz" Price to investigate possible sites, attendance expectations, cost, and numerous other questions. Buzz Price determined the economic feasibility and the best location for this new project. When Buzz asked Walt if he coveted a specific locale, the boss said, according to Price's recollections, "Absolutely not—you tell me where the best location is."

Buzz analyzed the top 10 potential sites in Orange County. Ultimately, Price and Walt and Roy Disncy selected 160 acres of orange groves in Anaheim, near the new Santa Ana Freeway, as its ideal location for Disneyland. When Walt first saw this site in 1953, it was a flat expanse without a river, mountain, castle, or rocket ships—a situation that quickly changed from orange groves and a few walnut trees near Anaheim, at the time a small town of 14,000 people.

The construction of Disneyland began on July 21, 1954, and the park opened on July 17, 1955, at a cumulative cost at that time of $17 million. From that day forward, Walt's life would never be the same. On the first day, 28,000 visitors entered the gates, some holding counterfeit tickets.

An aerial view shows the lands in Anaheim that would become Walt's Disney's Disneyland. In July 1953, Disney engaged the services of the Stanford Research Institute to find the ideal location for the film producer's "Mickey Mouse Park." The Stanford University Graduate School of Business decided that Anaheim would be the best location to build Disneyland. (Courtesy of the Orange County Archives.)

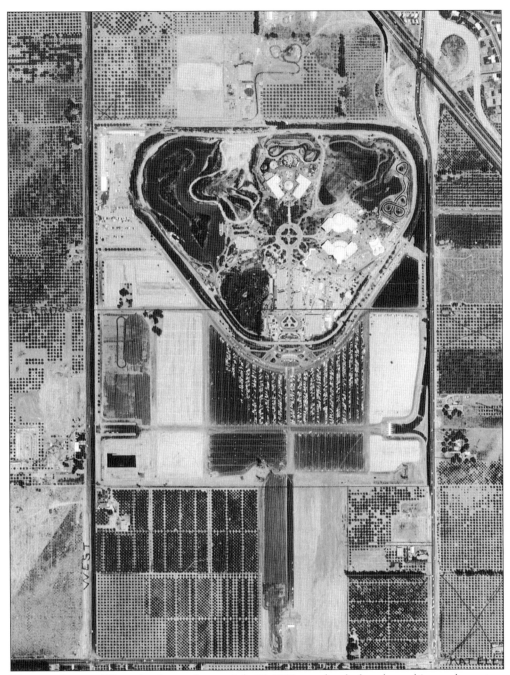

This aerial view of Disneyland was taken on July 15, 1955, two days before the park's grand opening. In the 1950s, Anaheim wasn't much of a destination spot, with very few draws for vacationers. In fact, when Disneyland opened, Anaheim had five hotels, two motels, and a total of 87 rooms. (Courtesy of the Orange County Archives.)

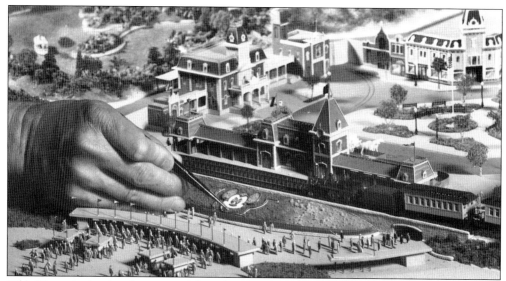

Walt Disney insisted on having models and statues at Disneyland. Walt's employees responded to the new challenges and helped out when troubles arose. For instance, there was some difficulty in obtaining architects' drawings from turn-of-the-20th-century buildings, so Ward Kimball, Walt's renowned animation director, contributed rare books of drawings from his own collection. This model is of the Main Street Station. (Courtesy of Walt Disney Resorts.)

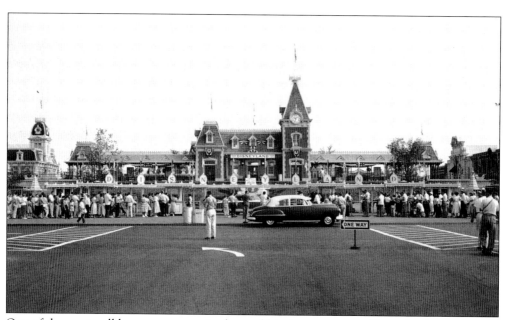

One of the most well known gateways in the world is the entrance to Disneyland, seen here in the late 1950s.

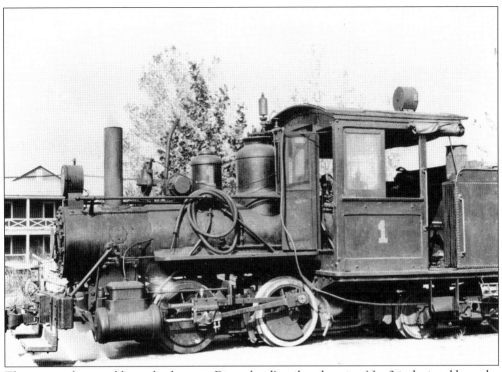

The engine that would one day become Disneyland's railroad engine No. 3 is depicted here the way she looked when discovered on the Godchaux Plantation in Louisiana. This tiny Baldwin locomotive was built in 1894 and served the Godchaux Plantation near New Orleans for many decades. It was sidelined by "progress": a modern diesel train took over its duties. (Courtesy of Steve DeGaetano.)

The No. 4 *Ernest S. Marsh* was originally the Raritan River Sand No. 10. The *Ernest S. Marsh* was first built as a saddle tanker in 1925 by the Baldwin Locomotive Works. It started operating in Disneyland in 1959. The Disneyland Railroad was, at one time, owned and operated by a separate company called Retlaw, which is Walter spelled backwards. (Courtesy of Steve DeGaetano.)

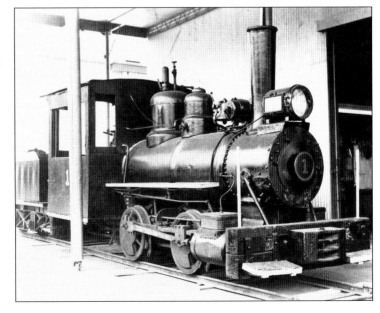

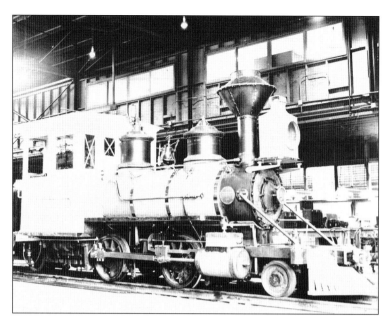

Walt Disney didn't like the look of the saddle tanks when he bought the No. 4 *Ernest S. Marsh*, so he ordered his shop men to build a separate tender for the locomotive and remove the saddle tanks. The original construction number on the engine is 58367. (Courtesy of Steve DeGaetano.)

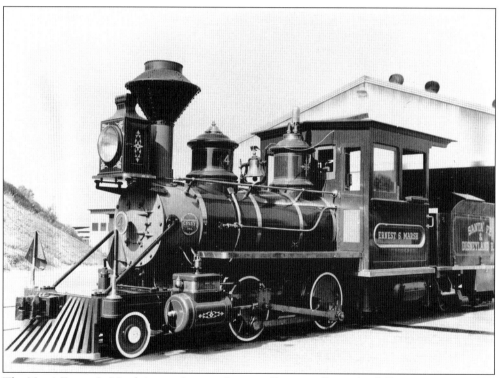

The No. 4 *Ernest S. Marsh* is seen here at the roundhouse at Disneyland. Disney trains put on about 20,000 miles annually in their circle routes around Disneyland. Until 1974, the Disneyland Railroad was sponsored by the Atchison, Topeka, and Santa Fe Railway, during which time it operated as the Santa Fe and Disneyland Railroad.

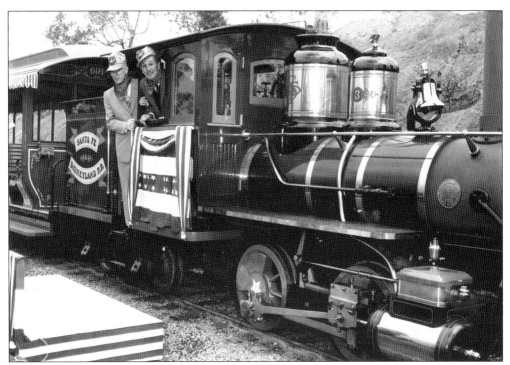

Walt Disney sits in the cab next to Fred Gurley (standing), president of the Santa Fe Railway. Disney would shortly drop the bunting on the cab side to reveal the locomotive's name. The locomotive now bears a shiny brass builder's plate near the front of the engine. (Courtesy of Steve DeGaetano.)

The Red Wagon Inn, on the "Plaza" at Disneyland, offers elegance and glamour reminiscent of famed eating houses of yesteryear. Turn-of-the-20-century furnishings are authentic mementos of the 1890s, including the stained-glass ceiling. The entrance hall and foyer were taken from a mansion on St. James Park in Los Angeles.

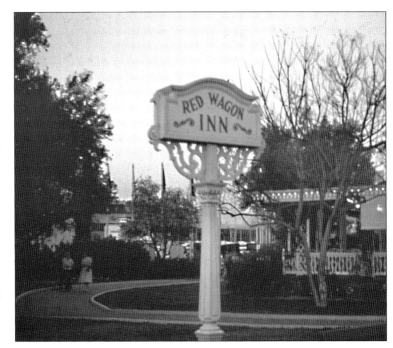

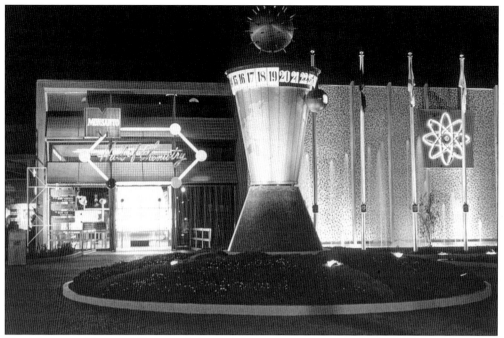

The Monsanto Chemical Company's first exhibit at the entrance of Disneyland's Tomorrowland was known as the Hall of Chemistry. Pictured here is the Clock of the World. Patrons were able to check the time anywhere in the world with this clock.

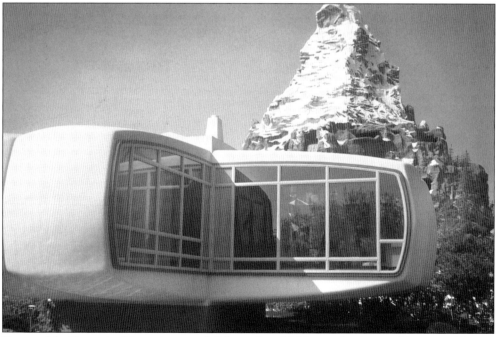

House of the Future had four wings, each 8 feet tall and 16 feet wide, that could support 13 tons. The Massachusetts Institute of Technology helped design the house for Walt Disney. Over 20 million guests visited the house while it was an attraction. The foundation was never removed and now functions as a planter at the entrance to Tomorrowland.

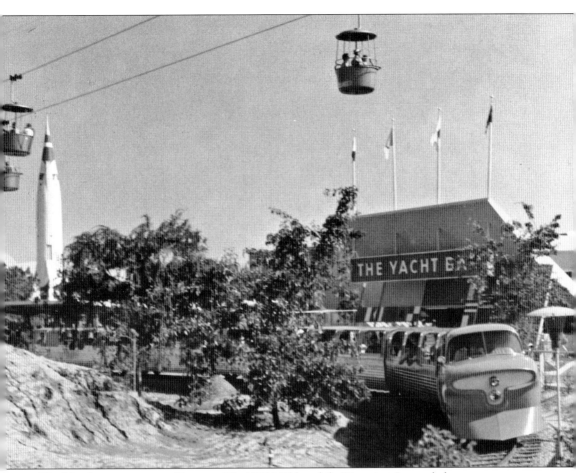

The Viewliner was powered by a modified 1954 Oldsmobile 88 engine. It traveled on narrow-gauge rails. There were two trains each with six cars. The trains were the salmon-colored Tomorrowland Viewliner and the blue Fantasyland Viewliner. Two stations tended to them. Tomorrowland station was located where the Monorail station is now, and the Fantasyland Station is near the Matterhorn. The track was a figure eight.

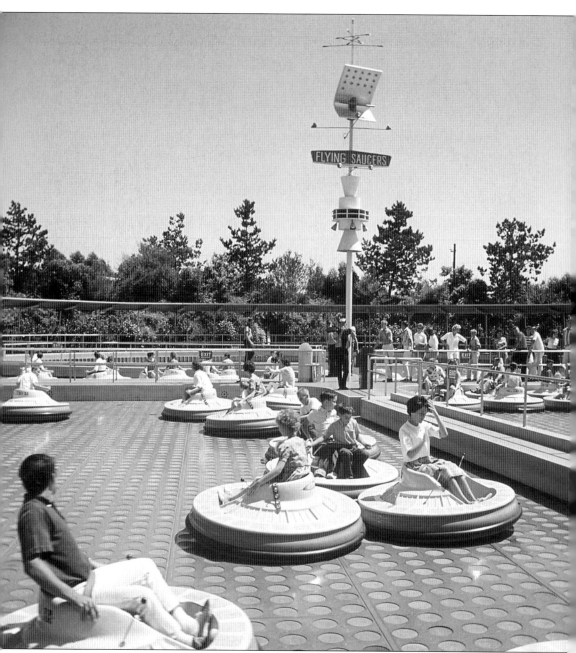

The Flying Saucers became one of Walt Disney's attractions for the 1961 summer season. Disneyland had been experimenting with the flying saucers in Northern California for months before they became a ride. Because of the air-cushion principle involved, each saucer had a self-contained unit in which one guest would be able to pilot his or her own ship in free flight. A total of 64 individual saucers were in operation.

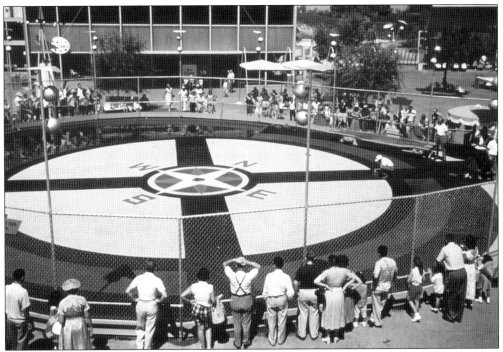

The Cox Flight Circle was where a person could watch a demonstration of gasoline-powered model planes, cars, and boats. The Cox Flight Circle operated in 1955 and 1956. The demonstration area featured Cox engines on U-control as well as some boat model demos.

The Midget Autopia made its debut in 1957. It was the third track at Disneyland and the smallest in the park, following the Tomorrowland Autopia track and the Junior Autopia in Fantasyland. The Midget Autopia closed in April 1966 to make way for a new path up to It's a Small World.

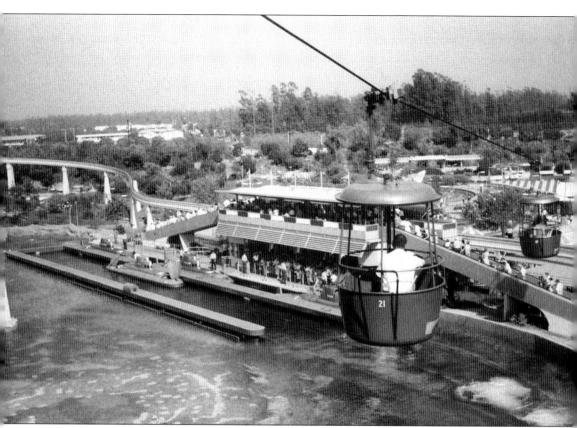

The Skyway to Tomorrowland or Fantasyland is seen here. The buckets would reach a height of 60 feet. The drive mechanism was located in the Fantasyland side with 35,000-pound ballast on the Tomorrowland side to keep the cable tight. The Skyway was built by Von Roll Iron Works of Bern, Switzerland. The first gondolas had metal patio chairs bolted in them.

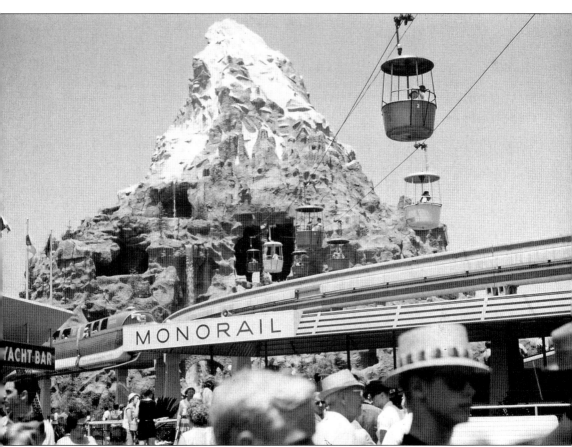

The Disneyland-ALWEG Monorail System opened on June 14, 1959, as a sightseeing attraction in Tomorrowland in Disneyland. In 1961, the track was lengthened to leave the park and stop at a station near the Disneyland Hotel. The Mark II trains were very similar to the Mark I versions, but two extra cars were added to the train to increase capacity.

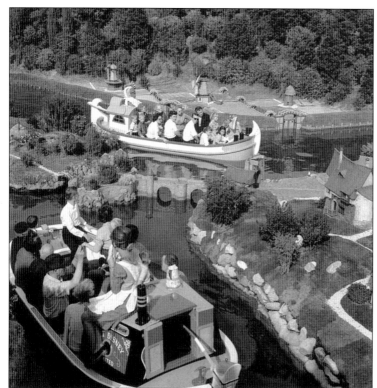

Storybook Land Canal Boats were originally powered by outboard motors, which would overheat often and had to be towed back into the dock. Then gasoline engines were so loud that the passengers could hardly hear the spiel. After a few months, the motors were powered by batteries hidden under the seats.

For the first summer, the Storybook Land Canal Boats were staffed by men. An all-male closing crew had the duty of manually pulling the boats into the storage area and connecting the battery cables to charge the boats overnight. Eventually electricians installed a two-way switch on the boats, providing a reverse gear to easily back the boats into the storage tunnel. Seen here is Monstro the Whale from *Pinocchio*. His eyes open and close and steam shoots out the blowhole.

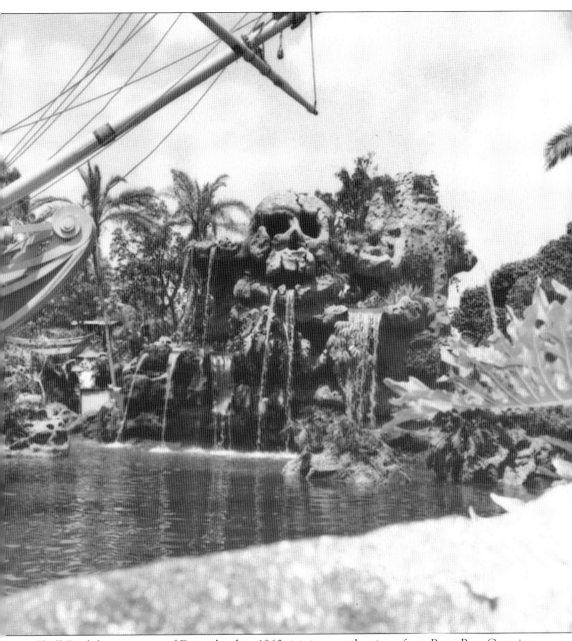

Skull Rock became part of Disneyland in 1960, joining another icon from Peter Pan, Captain Hook's Pirate Ship, which had been in Disneyland since 1955. Skull Rock and the Pirate Ship were both victims of the New Fantasyland project.

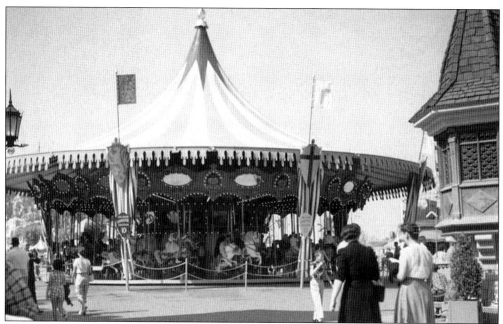

The King Arthur Carrousel is an original 1875 Dentzel carousel. Walt wanted all leaping horses. Each horse is different in carving and in painting. These 72 horses are in 18 rows, with four abreast. Hand-painted scenes from Sleeping Beauty grace the interior. The carousel had been operating in July 1954 at Sunnyside Park in Toronto, Canada, before being purchased for Disneyland.

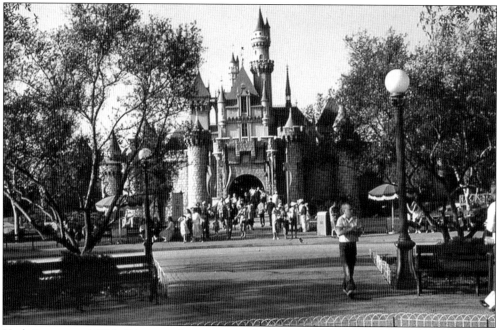

Herb Ryman and Walt Disney took inspiration from the castle of Neuschwanstein in Bavaria, one of King Ludwig II's fairy-tale castles. Herb Ryman thought the Disneyland version looked too much like Neuschwanstein, so he experimented with the model and turned the top of it around backwards. At that point, Walt Disney walked into the room and liked what he saw.

Disneyland's Peter Pan's Flight is a single-bench attraction. The original ride featured the vehicles flying through the nursery, out over London, onward to Neverland, and finally through Skull Rock. It is one of the few remaining attractions still in use that was operational on Disneyland's opening day in 1955. The ride's story is based on Disney's animated film version of the classic story.

When Disneyland opened, the Mule Pack was one of the park's original attractions. The attraction was enhanced in 1956 and became known as the Rainbow Ridge Pack Mules. With the next expansion in 1960, the mules traveled through Nature's Wonderland.

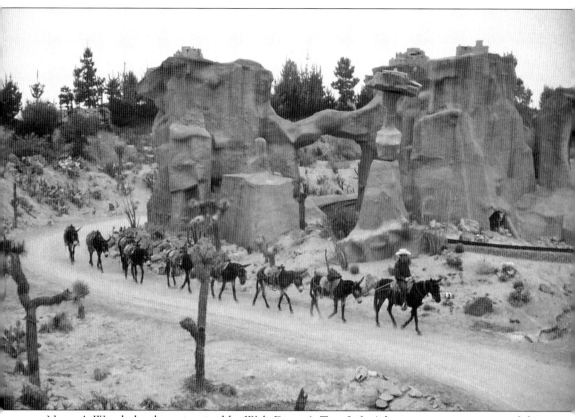

Nature's Wonderland was inspired by Walt Disney's True-Life Adventure nature movies of the 1950s. It was home to 200 lifelike, animated mammals, reptiles, and birds. The passenger train traveled through Bear Country, Beaver Valley, Living Desert, and Rainbow Caverns.

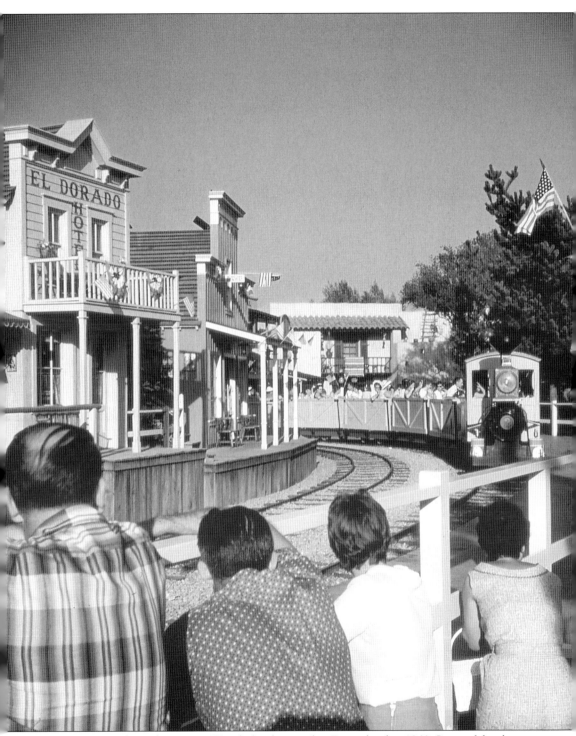

The Mine Train through Nature's Wonderland opened in Disneyland in 1960. Some of the things that patrons would see included waterfalls at Cascade Peak, beavers building a dam, brown bears swimming or resting, and even one bear scratching his back.

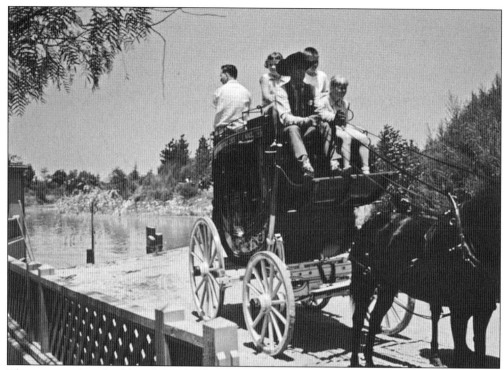

The stagecoaches, buckboards, and Conestoga wagons were drawn by horses. The stagecoaches operated in Frontierland and were among Disneyland's opening-day attractions. The Stagecoach ride was changed to Rainbow Mountain Stage Coaches in 1956 and, like the real deal, was retired itself, in 1959.

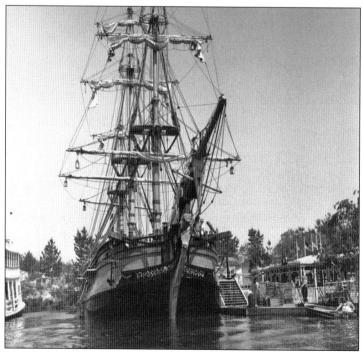

The sailing ship *Columbia* was a 10-gun, three-mast, 84-foot-tall vessel that is a full-scale replica of the first American ship to set sail around the world.

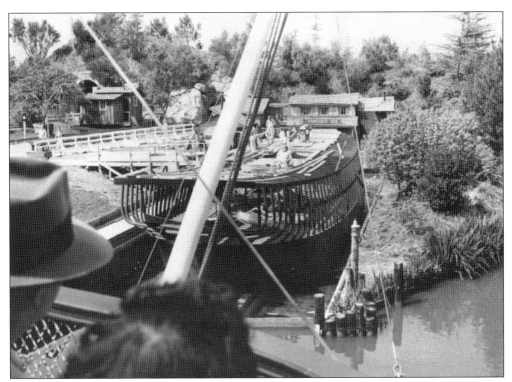

Architect Ray Wallace was commissioned by Walt Disney in 1957 to work with Adm. Joe Fowler to re-create a historical sailing ship from America's past. The *Columbia Rediviva* was chosen as the model for both its look and its place in history.

The *Mark Twain* weighs over 150 tons and stands 28 feet tall. The ship was designed by Roger Broggie, Dick Bagley, and Roland Peterson. They used historic riverboats such as the *Little Rufus* and the *Natchez* for their inspiration. The hull was built at Todd Ship Yards in San Pedro, California. The structure was built at the Disney Studios.

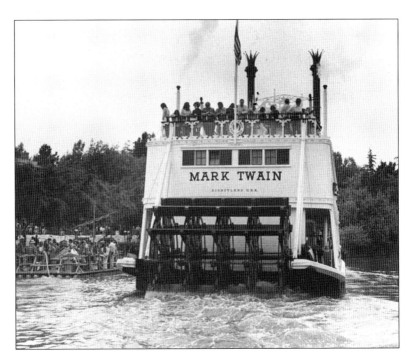

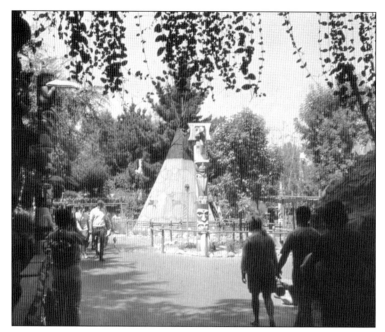

Frontierland's Indian Village was located on the shores of the Rivers of America exhibit. Representing various tribes, Indian Village would present the culture and customs as well as the arts and crafts of Native Americans.

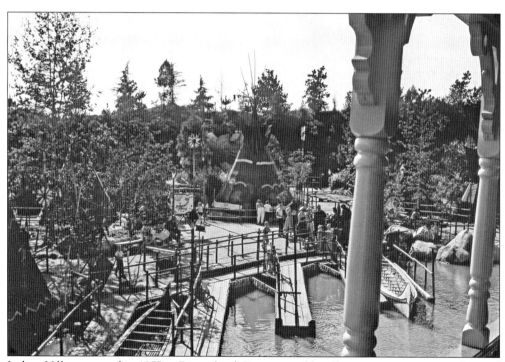

Indian Village opened in 1955 at Disneyland. Patrons could walk past teepees, totem poles, and a burial ground. Dances were enacted at the Ceremonial Dance Circle. Visitors could board one of the Native American war canoes and take a ride around the Rivers of America. All they had to do was supply the oar power.

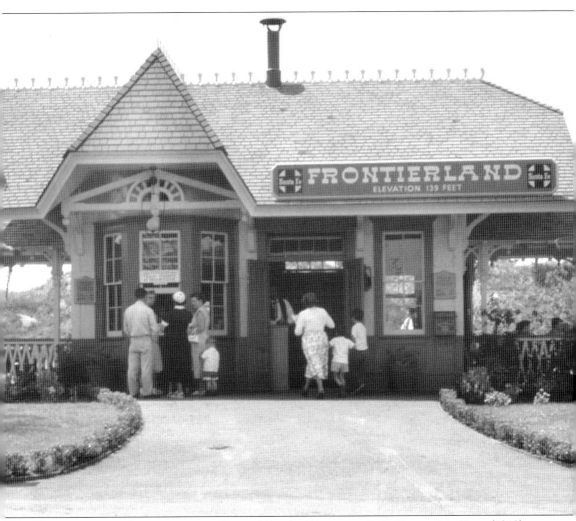

The train station design was originally used for the Disney movie *So Dear to My Heart* (1948), starring Burl Ives and Bobby Driscoll. After the movie was made, Walt gave Ward Kimball the movie facade for his backyard layout. Ward turned that facade into the real thing, a three-dimensional facsimile. Walt was impressed and had one built for his park in Frontierland at the train station. It is still at Disneyland today.

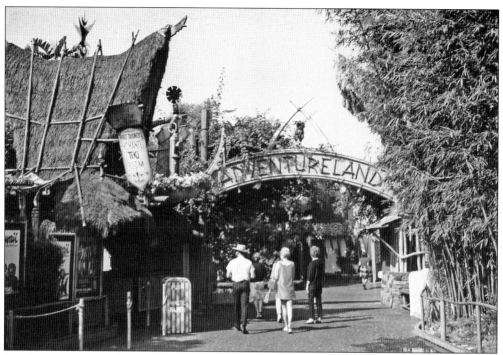

The Tiki Room opened on June 23, 1963, as the first to feature an "Audio-Animatronics" attraction, designed by WED Enterprises. The attraction's first commercial sponsor was United Airlines.

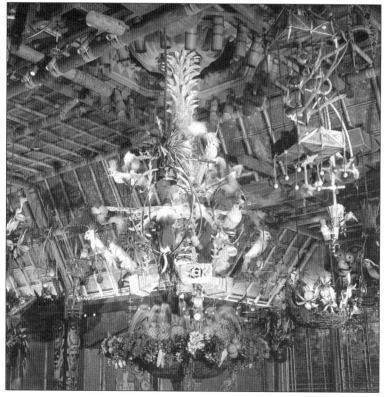

The Tiki Room has a cast of over 150 talking, singing, and dancing birds as well as flowers and other plants. The attraction's signature tunes are "In The Tiki Tiki Tiki Room" and "Let's All Sing Like the Birdies Sing." These songs were done by the Sherman Brothers, Richard M. Sherman, and Robert B. Sherman.

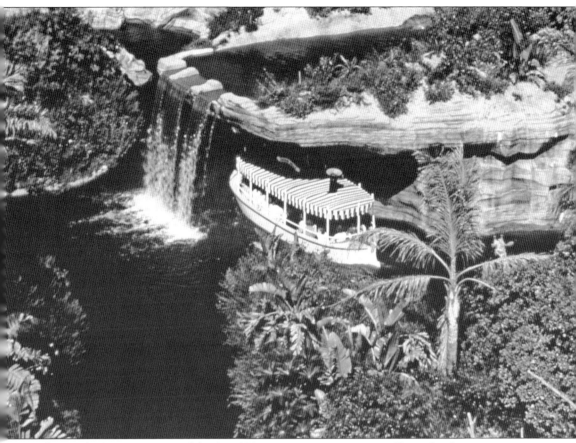

The Jungle Cruise was one of the first 22 attractions in operation at Disneyland on its opening day in 1955. The boats are modeled after the craft seen in the movie *The African Queen* (1952), which starred Humphrey Bogart and Katharine Hepburn. The Imagineers originally dyed the water brown to prevent visitors from seeing the bottom of the "river," which ranges from 3 to 8 feet deep.

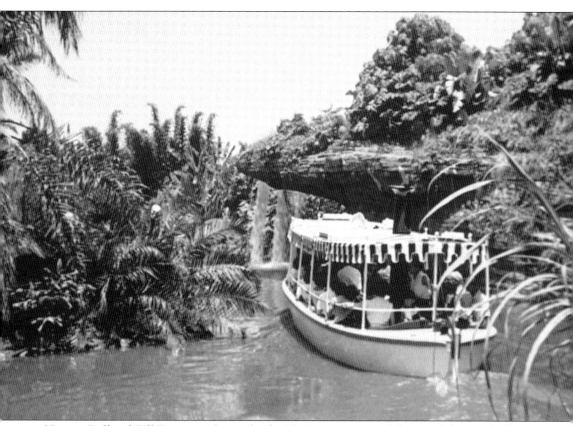

Harper Goff and Bill Evans can be credited with the creation and design of the Jungle Cruise ride. Evans was the landscape architect who planted a group of orange trees upside down so the gnarled roots would look like exotic jungle branches on Disneyland's Jungle Cruise.

Some of the members of The Mickey Mouse Club television show's cast of Mouseketeers performed in two circus shows on the outskirts of Fantasyland. On Thanksgiving Day 1955, the Mickey Mouse Club Circus debuted with a parade down Main Street USA. The circus was poorly received and discontinued in February 1956. The circus was replaced by Keller's Jungle Killers. George Keller continued doing his Keller's Jungle Killers animal show until September 7, 1956.

The Mickey Mouse Club had two shows a day, including Christmas and New Year's Day. Walt Disney loved circuses. The guests at Disneyland preferred to see the attractions. On January 8, 1956, the circus closed.

GOOD FOR
CHOICE of ONE **25¢ "B"** JUNIOR
ADMISSION
SPECIAL TICKET BOOK PRICE 20¢

Disneyland

MAIN STREET MAIN ST. CINEMA

TOMORROWLAND ART OF ANIMATION EXHIBIT

FANTASYLAND CASEY JR. CIRCUS TRAIN

F 187470 or any other "B" attraction

B COUPON

Pictured here is the memory of a Disneyland visit. The tickets, lettered A through E, were used for admission to each attraction. When the park first opened on July 17, 1955, a Main Gate admission price and each ride or attraction cost between 10 and 35¢.

GOOD FOR
CHOICE of ONE **45¢ "D"** JUNIOR
ADMISSION
SPECIAL TICKET BOOK PRICE 35¢

Disneyland

TOMORROWLAND SKYWAY TO FANTASYLAND

FANTASYLAND PETER PAN FLIGHT
SNOW WHITE'S ADVENTURES
MR. TOAD'S WILD RIDE
STORYBOOK LAND CANAL BOATS
ALICE IN WONDERLAND
SKYWAY TO TOMORROWLAND

FRONTIERLAND MARK TWAIN STEAMBOAT

F 187470 or any other "D" attraction

D COUPON

Walt Disney introduced lettered tickets in October 1955, just a few months after opening Disneyland. The "D" tickets were added in the middle of 1956 and the famous "E" ticket was introduced in June 1959 with the opening of the Matterhorn, Monorail, and Submarine attractions.

Four

HOLLYWOOD AND ENTERTAINMENT ATTRACTIONS

Grouped into this chapter are three attractions that catered to visitors' understanding of the movies, television, and the general entertainment scene: Movieland of the Air Museum in Santa Ana, Movie World Cars of the Stars/Planes of Fame Museum in Buena Park, and Movieland Wax Museum, also in Buena Park.

Renowned Hollywood aviators Paul Mantz and Frank Tallman combined their fleets of airplanes into TallMantz Aviation, Inc., and created the Movieland of the Air Museum, which opened at Orange County Airport on December 14, 1963. All of the aircraft in the museum were airworthy and were flown regularly. Visitors found more than 50 rare airplanes on 5 acres both inside a large hangar and out. The exhibited historical aircraft, replicas, and artifacts were available as rentals to motion-picture studios and advertising agencies. Mantz, perhaps the most famous aviator in Hollywood history, was killed in a crash on location to complete flying sequences for *The Flight of the Phoenix* (1965), starring James Stewart.

James F. Brucker's auto museum in Oxnard, Ventura County, and Edward T. Maloney's airplane museum in Ontario, San Bernardino County, merged into this Buena Park attraction. Brucker, a former farmer, collected cars for fun, 700 of them, and rented them to moviemakers. Brucker and his son, Jimmy, opened Movie World Cars of the Stars/Planes of Fame Museum in Buena Park in 1970. The Bruckers had teamed up with Ed Maloney to have a dual air and ground attraction. The concern had hoped to capitalize on the crowds that were drawn to Buena Park by Knott's Berry Farm and the Movieland Wax Museum, but the location a mile from Beach Boulevard proved to be too distant. The museum lasted from 1970 to 1979.

Entrepreneur Allen Parkinson, who developed the over-the-counter sleeping aid Sleep-Eze, bought acreage near Knott's Berry Farm and opened Movieland Wax Museum in 1962. Parkinson spent $1.5 million on a 20,000-square-foot building that had a Hollywood studio feel. On opening day, visitors could scrutinize 60 life-size likenesses of contemporary and early-day stars in scenes from memorable motion pictures. Parkinson sold the museum along with the Japanese Village and Deer Park (seen later in this book) to the Six Flags Corporations for $10 million in 1970. The museum closed its doors after Halloween 2005 after 43 years in operation.

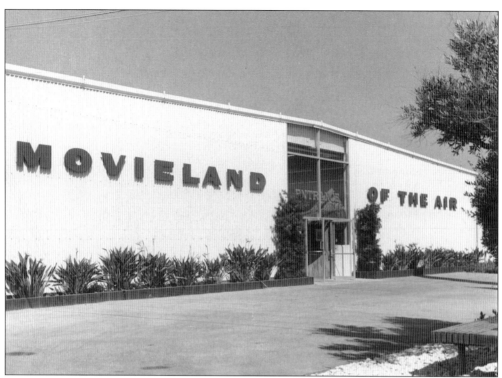

A large hangar had to be constructed for the Movieland of the Air Museum along the owners' adjoining business offices, and a fenced off-ramp area was created to house the aircraft for display. The main entrance was adorned with a missile pointing skyward. Visitors were immediately struck by a dozen or more aircraft that lined the sides of the display hangar, with the thoughtful dioramas placed behind the aircrafts representing the craft, era, or, more often, the film in which it had been flown.

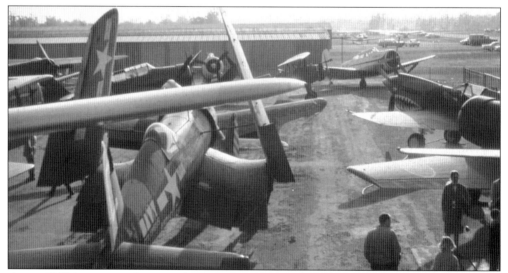

Active TallMantz aircraft were to be parked on the ramp in front of the museum. In December 1963, the grand opening proved it to be a popular attraction in tourist-rich Orange County, which also boasted Disneyland, Knott's Berry Farm, and the Movieland Wax Museum.

Sprinkled throughout the hangar were displays with hundreds of photographs, most from Mantz or Tallman movie projects, with press clippings, movie posters, and pertinent information about each of the aircraft. Attendance at the museum dwindled in the 1970s. Tallman was killed in 1978 in a plane crash on Santiago Peak in the Santa Ana Mountains. The museum remained open for the balance of the company's operation under its original management. When company president Frank Pine passed away in 1984, the Tallman and Pine families liquidated the collection and sold the company.

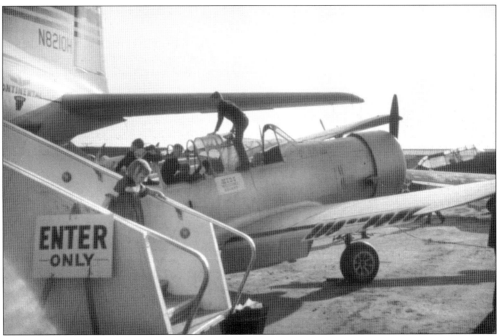

Some of Mantz's and Tallman's movie projects were *A Gathering of Eagles* (Universal-International, 1962), *The Longest Day* (20th Century Fox, 1962), *It's a Mad, Mad, Mad, Mad World* (United Artists, 1963), *Those Magnificent Men in Their Flying Machines* (20th Century Fox, 1965), *In Harm's Way* (Paramount, 1965), *Battle of Britain* (United Artists, 1969), and *The Great Waldo Pepper* (Universal-International, 1975)—to name a few.

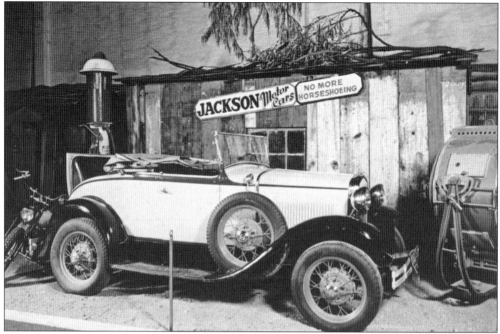

This vintage vehicle at the Cars of the Stars Museum was used in the violent, action-packed film *Bonnie and Clyde* (1967), starring Warren Beatty, Faye Dunaway, and Gene Hackman. Arthur Penn directed the influential movie about Midwestern bank robbers during the Great Depression. The Bruckers displayed 150 vehicles at Buena Park. (Courtesy of Dan Brucker.)

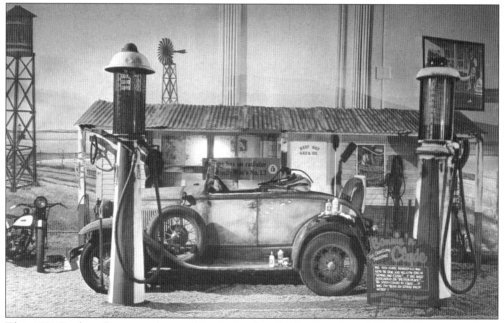

This 1931 Ford roadster was also used in the landmark film *Bonnie and Clyde*. There were also a number of creations fabricated by Ed "Big Daddy" Roth, the king of the custom carmakers. The museum served as patrons for the "Kustom Kulture" movement. It also contained dozens of prominent films scenes and props from hundreds of motion pictures. (Courtesy of Dan Brucker.)

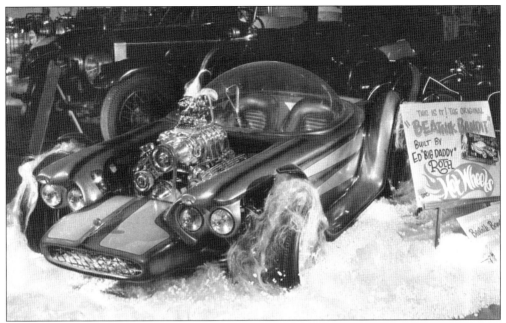

Built by Ed "Big Daddy" Roth, the "Beatnik Bandit" is one of the most recognized custom show cars of its time; built on a 1955 Oldsmobile chassis, it is powered by an Olds engine. The car was constructed from fiberglass and had twin Ford carburetors. The car had joystick steering control, a feature under the Bandit's custom bubble top. (Courtesy of Dan Brucker.)

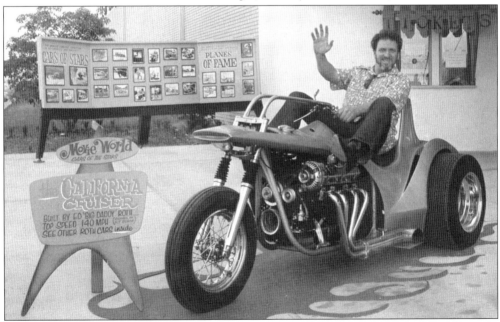

Big Daddy Roth is seen here with his famous V-8-powered "California Cruiser," one of the many custom bikes and cars that were on display at the Movie World Cars of the Stars Museum. The Bruckers hired Big Daddy as their art director, and he spent most of his Sundays at the museum working on his latest creations. Wheels and a pile of plaster of paris could be seen through the glass doors of the museum lobby. (Courtesy of Dan Brucker.)

The "Outlaw" was Ed Roth's first car that he created using his special plaster and fiberglass method. Ed originally named this car "Excalibur" after his mother-in-law's family's Revolutionary War sword, which was used as the shifter (and, in turn, named after the blade in the stone from the King Arthur legend). However, people had problems pronouncing the word. (Courtesy of Dan Brucker.)

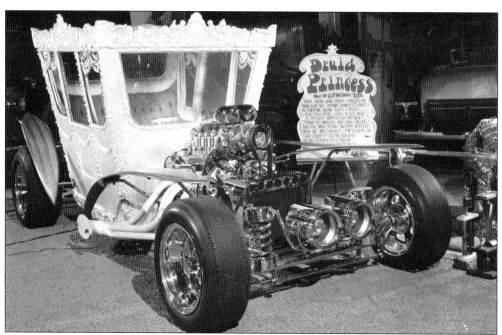

Another one of Ed Roth's unique creations was the "Druid Princess." From its deco pieces that decorated the body to the Watson's special paint technique called veiling, the Druid Princess was a real showstopper. A Dodge engine and transmission supplied the power, and the blower mounted on top has a carburetor inside for easier starting at shows. (Courtesy of Dan Brucker.)

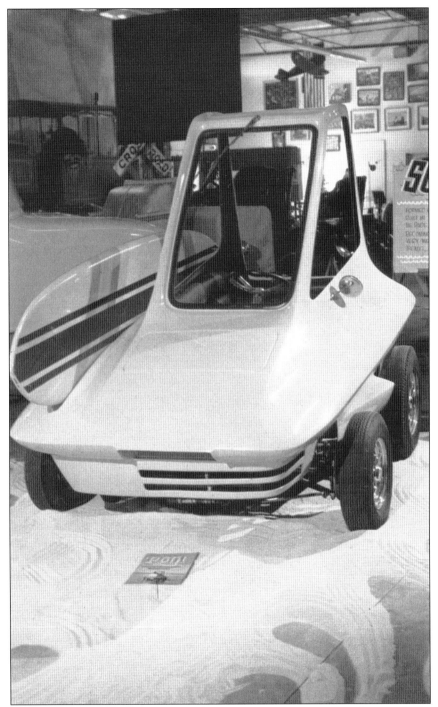

The "Surfite" was a genuine surfer's car. Under its unique custom surfboard-carrier body was an Austin Mini Cooper chassis. Power was supplied by a 1,269-cc Austin Mini Cooper chrome-plated engine. This Movie World Cars of the Stars item was designed by Ed Roth and Ed Newton. Note the handy surfboard rack on what would be the passenger side of almost any other car. Ed Roth's vehicles often only had room for one—the driver. (Courtesy of Dan Brucker.)

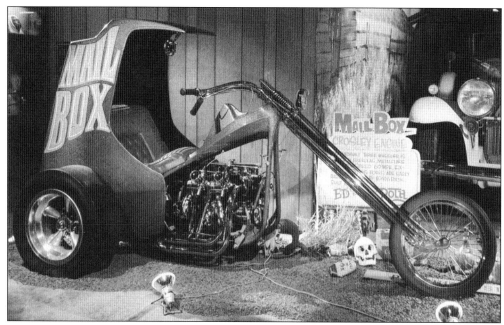

Originally built by Jim "Jake" Jacobs, then traded to Ed Newton and finished off by Ed Roth, the "Mail Box" was powered by a Crosley four-cylinder engine. By the time this bike was completed, Ed Roth was really into creating "trikes." (Courtesy of Dan Brucker.)

Ed Roth's "Road Agent" is pictured here. It was the first of many of Ed's rear-engine show cars. Ed used a Corvair engine and a uniquely placed upside-down Corvair transmission. Other features include a frame made from chrome moly tubing and a 1937 Ford suspension with a single Volkswagen torsion bar. This car cost $1,500 to build and took a year's worth of intricate construction. (Courtesy of Dan Brucker.)

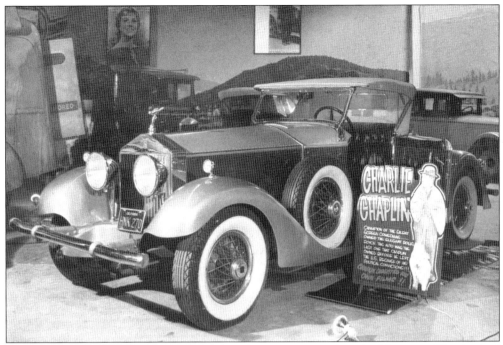

Charlie Chaplin, the famous Tramp of the silent-screen era, cherished his cars. Chaplin had this car custom built on a Rolls Royce chassis in 1929. It found its way into the Cars of the Stars collection. (Courtesy of Dan Brucker.)

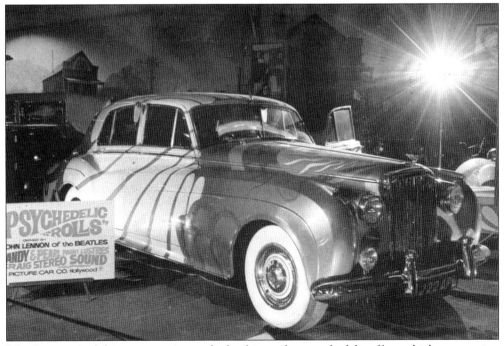

John Lennon had this custom paint applied to his car for a psychedelic effect, which was on view at the Cars of the Stars. (Courtesy of Dan Brucker.)

Steve McQueen's Solar Productions was instrumental in the production of the move *The Reivers* (1971), based on a William Faulkner novel. McQueen went to his friend Von Dutch to construct this movie car. The "Winton Flyer" had to combine a four-passenger capacity and 1904 appearance with the practical requirements of strength and reliability for the shooting schedule it demanded. (Courtesy of Dan Brucker.)

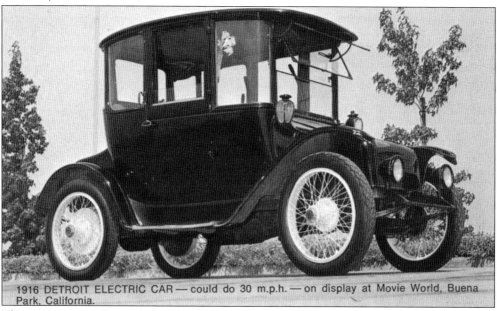

1916 DETROIT ELECTRIC CAR — could do 30 m.p.h. — on display at Movie World, Buena Park, California.

This car was manufactured in 1916 by the Anderson Electric Company in Detroit, Michigan. The company produced electric vehicles from 1906 until the 1930s, but the name was changed to the Detroit Electric Company in 1919. They produced about 14,000 electric cars over this period. The car was totally enclosed and easy to operate. This antique vehicle was seen at the museum. (Courtesy of Dan Brucker.)

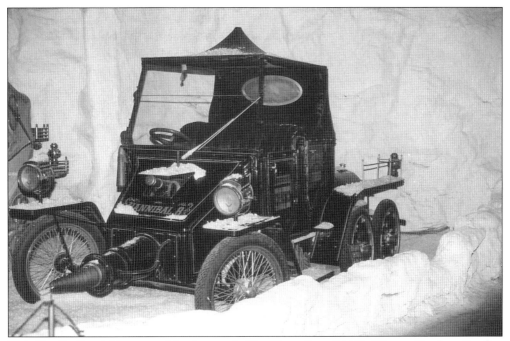

This "Leslie Special" appeared in the movie *The Great Race* (1965). Warner Brothers Studios constructed this (and another one just like it) for the comedy, starring Tony Curtis as the Great Leslie, Natalie Wood as Maggie Dubois, Jack Lemmon as Professor Fate, and Peter Falk as Max. The story was that of a race from New York to Paris shortly after the dawn of the 20th century. (Courtesy of Dan Brucker.)

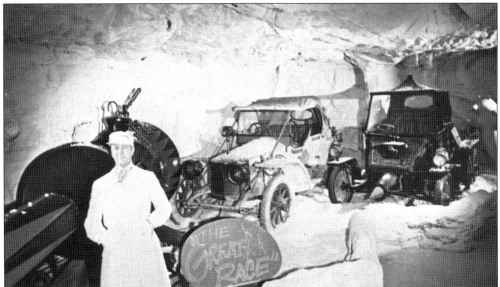

This chilly-looking scene also presented the Leslie Special from *The Great Race*, which starred Jack Lemmon as Professor Fate, whose ominous-looking vehicle is partially seen behind the cardboard cutout of Lemmon. Director Blake Edwards's film also featured Natalie Wood. The frigid-looking backdrop represents part of the efforts taken by Movie World Cars of the Stars to dress the sets the way an art director would on an actual motion-picture set. (Courtesy of Dan Brucker.)

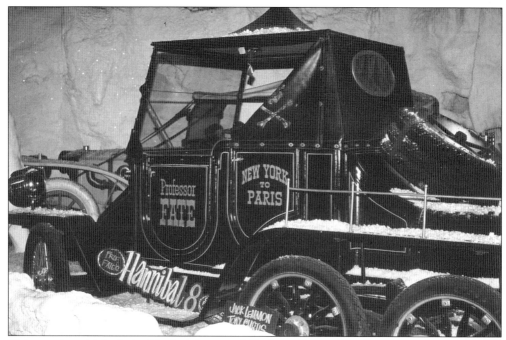

This was the vehicle devised for Jack Lemmon's Professor Fate in *The Great Race*, the granddaddy of all road comedies. Its wheelbase could be widened and its body could be raised overtop of other vehicles so that it could drive over them. (Courtesy of Dan Brucker.)

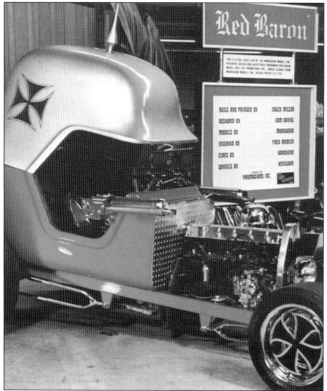

The "Red Baron" show car at Movie World Cars of the Stars was inspired by the Monogram Model kit by the same name. Chuck Miller was commissioned to be the custom car builder. The Red Baron was originally designed by Tom Daniel for Monogram Models, and converting the design to full scale was much easier said than achieved. The Red Baron was powered by a Pontiac overhead-cam, six-cylinder engine. (Courtesy of Dan Brucker.)

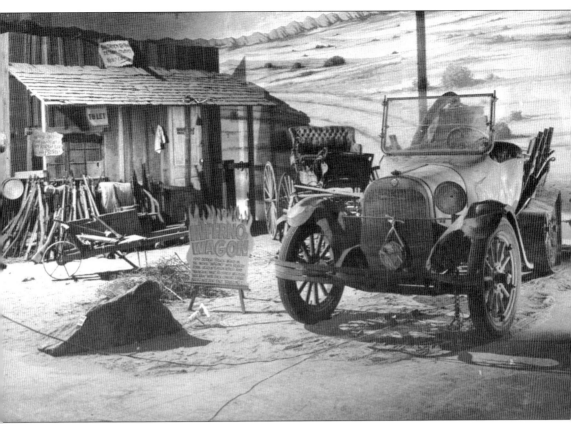

This Prospectors Shack has a 1919 Dodge that appeared in the movie *Inferno* (1953), starring Robert Ryan as a millionaire who breaks his leg on a desert excursion and Rhonda Fleming as his wife, who leaves him to die in the heat, running off with secret paramour William Lundigan. Roy Ward Baker directed the film. This shack set is representative of the types of exhibits that were standard at Cars of the Stars—filled with props and atmospheric bric-a-brac that placed the automobiles and other vehicles within the context of stories. This ramshackle-looking vehicle went right along with the shack. The car was also seen extensively on the television program *Hee Haw*, starring Buck Owens and Roy Clark. It fit right in with the other props from that show's fictional locale of "Kornfield Kounty." (Courtesy of Dan Brucker.)

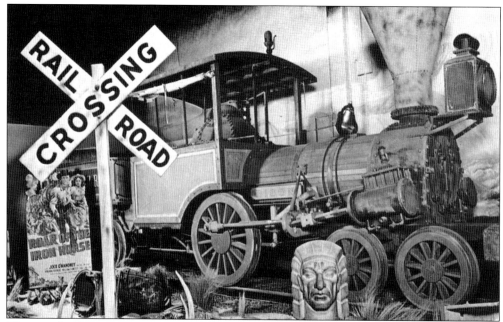

This wooden locomotive was used in the epic *How the West Was Won* (1963), which ended in a famous gun battle between lawman George Peppard and bandit Eli Wallach aboard the train. The locomotive, which was used in other pictures, was a full-size replica of an Old West locomotive. It was built by the studio prop department entirely out of wood, including the rivets, bolts, wheels, and fittings. (Courtesy of Dan Brucker.)

In the ABC series *Happy Days*, the Cunningham family car was this DeSoto, driven around the family's pleasant 1950s suburban Milwaukee neighborhood by Howard and Marion Cunningham (Tom Bosley and Marion Ross) and occasionally Richie (Ron Howard). Fonzie (Henry Winkler) was known to look under the hood. (Courtesy of Dan Brucker.)

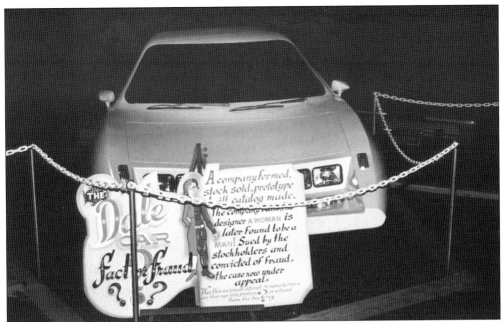

The Dale was built by Dale Clift and aggressively marketed by Elizabeth Carmichael in 1974 as the answer to gasoline prices. The Dale would cost $2,000 and get 70 miles to the gallon, according to Carmichael's claim, including to Johnny Carson on *The Tonight Show*. She said she was creating Twentieth Century Motor Car Corporation in Burbank, Los Angeles County. She ended up going to prison for fraud. The one at Movie World Cars and Stars was one of only two prototypes ever built.

Ed Roth originally planned to use a small Honda bike for "Rat Fink," but it needed four wheels so it wouldn't tip over. So he used a Cadillac electric-starter motor for power and put it all together on a small kart frame. (Courtesy of Ilene Roth.)

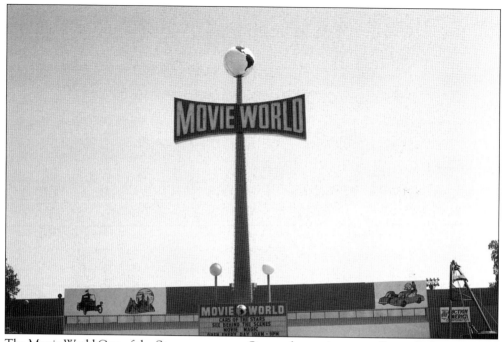

The Movie World Cars of the Stars marquee on Orangethorpe Avenue in Buena Park was topped by a T-shaped sign on a lamppost. (Courtesy of Rick Bastrup.)

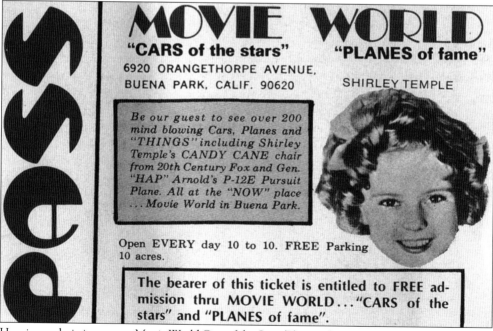

Here is an admission pass to Movie World Cars of the Stars/Planes of Fame Museum on Orangethorpe Avenue in Buena Park. Among the exhibits advertised on the pass was Gen. Henry T. "Hap" Arnold's P-23E Pursuit plane.

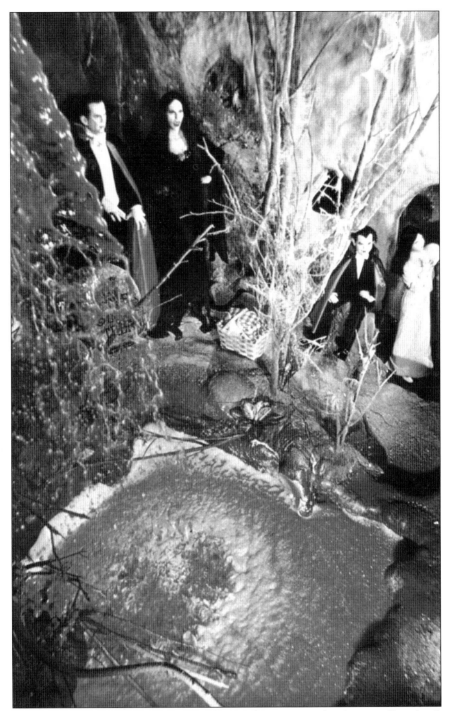

The Movieland Wax Museum had very few figures that were used to being still and pale more than Count Dracula. The Buena Park venue, which opened in 1962, had a spot for the great bloodless one. The Dracula family needed a summer home and went batty when they found this spot. The property had cold-running blood and was beautifully landscaped with a cemetery that slept six. (Courtesy of Dan Brucker.)

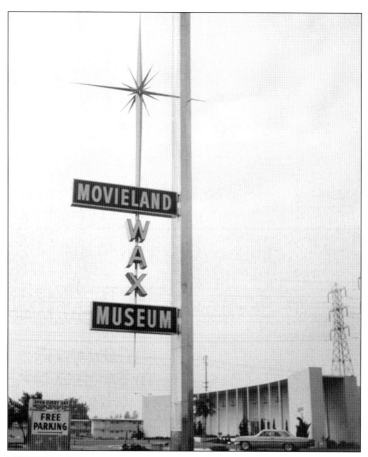

On opening day, the Movieland Wax Museum had 60 life-size likenesses of contemporary and early-day stars, posed in scenes from their most memorable motion pictures. The inside of the museum is made to give visitors the simultaneous feel of a Hollywood studio and a theatrical production.

Allen Parkinson hoped that his Movieland Wax Museum would become another Madame Tussaud's, the wax museum franchise operation located in New York, London, Hong Kong, and other cities. Unlike Madame Tussaud's, the wax museum had no chamber of horrors.

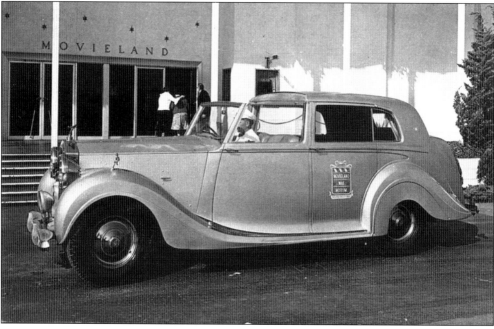

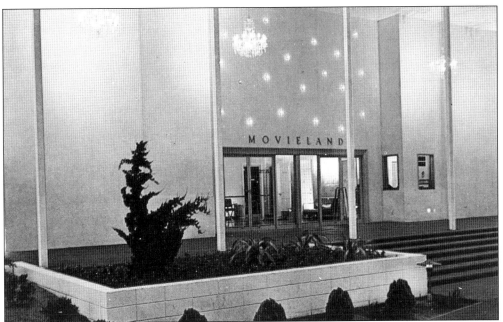

Parkinson ended up building the largest wax museum in the United States. The curved front portico had 10 large crystal chandeliers. The museum was housed in a gleaming white building, and the interior was sumptuously appointed throughout.

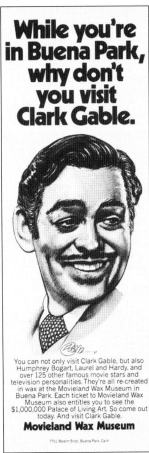

While you're in Buena Park, why don't you visit Clark Gable.

You can not only visit Clark Gable, but also Humphrey Bogart, Laurel and Hardy, and over 125 other famous movie stars and television personalities. They're all re-created in wax at the Movieland Wax Museum in Buena Park. Each ticket to Movieland Wax Museum also entitles you to see the $1,000,000 Palace of Living Art. So come out today. And visit Clark Gable.

Movieland Wax Museum

7711 Beach Blvd. Buena Park, Calif.

The Movieland museum did very little in the way of advertising, only using a few brochures. It depended upon the proximity of the nearby Knott's Berry Farm to help attract its customers. Here is one example of their advertising. (Courtesy of David Oneal.)

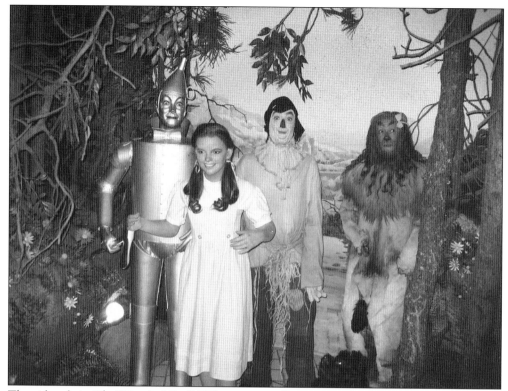

The title role in *The Wizard of Oz* (1939) was originally written with W. C. Fields in mind. Ray Bolger was originally cast as the Tin Woodsman. However, Bolger insisted that he would rather play the Scarecrow. In the original Oz movie, there was to be a large subplot involving characters named Princess Betty and the Grand Duke of Oz.

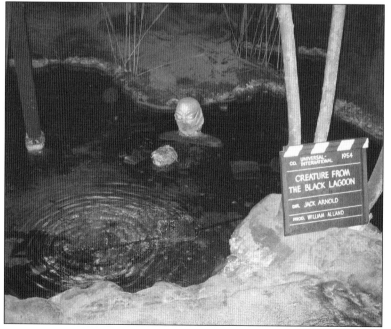

The Creature from the Black Lagoon (1954) starred Richard Carlson, Julia Adams, and Richard Denning. The eponymous creature was played by Ben Chapman on land and Ricou Browning in underwater scenes.

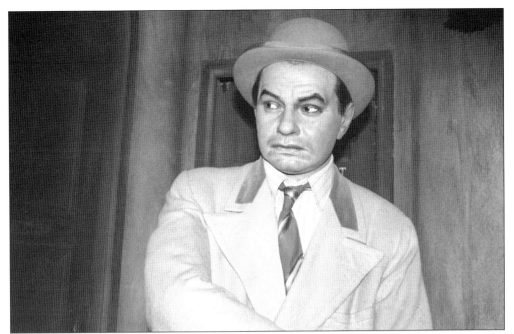

The Movieland Wax Museum temperature was kept in a range from 67 to 72 degrees. Wax melts at 120 degrees. Movieland had 125 sets with wax figures that cost between an average of $200 and $2,500 each. The museum had no backup generator to keep the statues cool if power was lost. Seen here is the likeness of Edward G. Robinson.

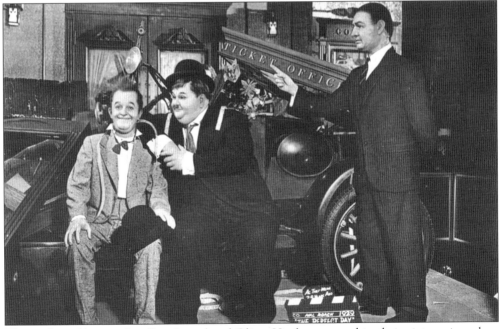

The quality of humor that Stan Laurel and Oliver Hardy generated in their pictures is ageless. One understands their resigned frustration in *Perfect Day* (1929) as they perch on an old Model T's running board. The car's radiator spouts steam after having demolished the box office of the Bijou Theatre— another fine mess.

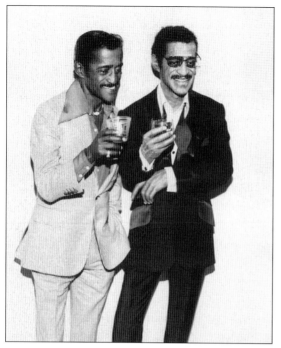

Will the real Sammy Davis Jr. please belt out a tune? A number of movie stars visited Movieland in person in its history. Mary Pickford dedicated the new museum when it first opened in 1962. Over the years, Jimmy Stewart, George Burns, Dudley Moore, Ed Asner, Buster Keaton, Carol Burnett, Mae West, Sammy Davis Jr., Roger Moore, and the principal cast of *Star Trek* came to pay their respects. (Courtesy of Rodney Fong.)

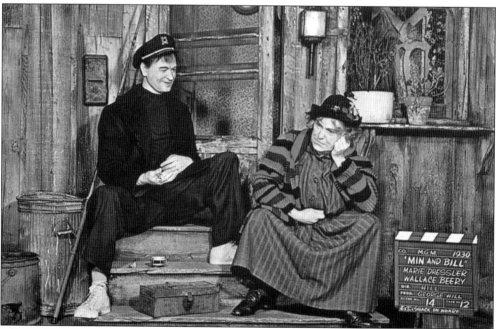

All the small signs, mostly clapboards, posted near each set in the Movieland Wax Museum were rife with movie lore and details. They not only include the names of each of the wax figures, but they also provided facts about the movies, actors, props, and costumes involved. For instance, Gary Cooper's mother donated costumes to the museum. Here the sign is located in the lower right-hand corner for an exhibit on *Min and Bill* (1930), a huge hit of the 1930s. Min owned the waterfront hotel where Bill, the captain of a fishing boat, lives. Wallace Berry and Marie Dressler starred. (Courtesy of Rodney Fong.)

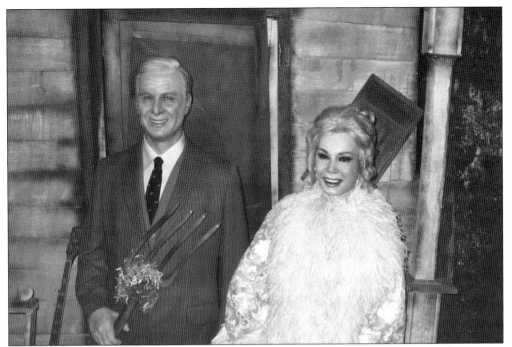

Green Acres was the brainchild of writer Jay Sommers and creative writer/producer Paul Henning. Every episode was directed by longtime Newport Beach resident Richard Bare. Successful lawyer Oliver Wendell Douglas leaves behind the complications of modern society and life in New York against the protestations of his glamorous, socialite wife, Lisa, and buys a farm, sight unseen.

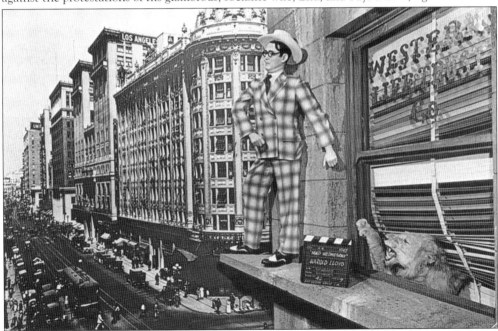

Harold Lloyd was famous for his silent comedies, ranking with Charlie Chaplin and Buster Keaton as one of the most popular and influential film comedians of the silent-film era. Lloyd made nearly 200 comedies, both silent and "talkies," between 1914 and 1947.

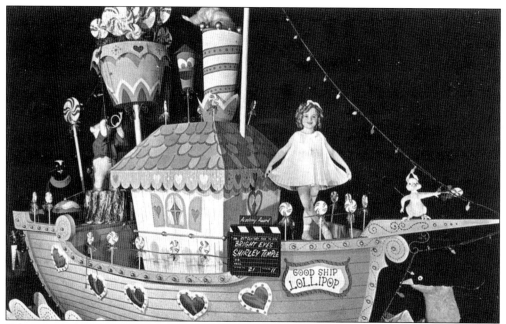

When Movieland Wax Museum opened in 1962, it contained scenes from John Huston's *The African Queen* (1952), Shirley Temple and "The Good Ship Lollipop," and Laurel and Hardy comedies. Also present were wax likenesses of dozens of film greats as well, including Rudolph Valentino and James Dean. At its peak in the 1960s, Movieland would draw as many as 1.2 million visitors a year. (Courtesy of Rodney Fong.)

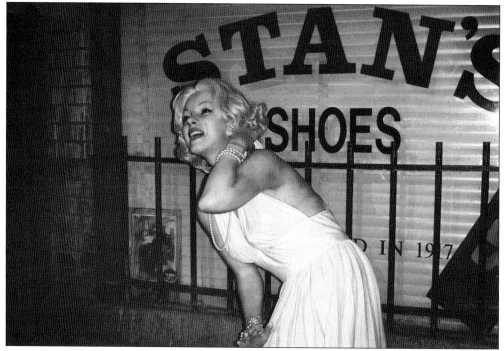

Gentlemen Prefer Blondes (1953) was based on the novel by Anita Loos. The movie was directed by Howard Hawks for Twentieth Century Fox and starred Marilyn Monroe and Jane Russell.

Roy Rogers was a folksy, straight-shooting Western hero. Born Leonard Slye, Rogers first entered the movie business as a member of his singing group, the Sons of the Pioneers. Rogers's singing career includes "Tumbling Tumbleweeds," performed when he was with the Sons of the Pioneers. Roy's horse was Trigger.

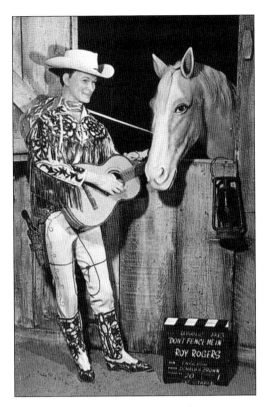

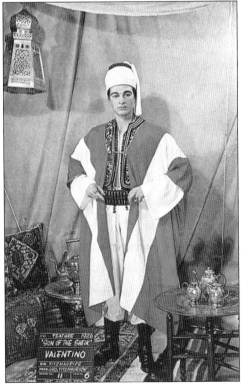

In the silent film *The Sheik* (1921), Sheik Ahmed was played by Rudolph Valentino. Ahmed desperately desires feisty British socialite Diana, so he abducts her and carries her off to his luxurious desert tent-palace. Valentino was born Rodolfo Alfonso Raffaello Piero Filiberto Guglielmi in Castellaneta, Italy, in 1895. He died in 1926 because of peritonitis brought on after surgery for a perforated ulcer.

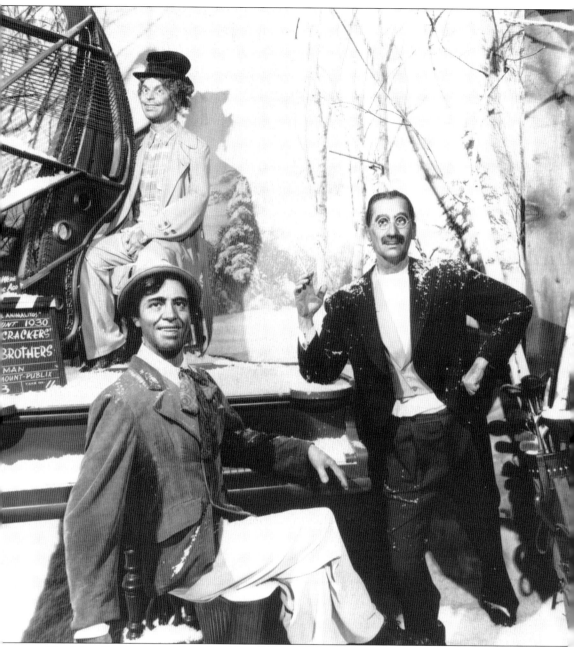

The Marx Brothers were Groucho, Harpo, Chico, usually Zeppo, and sometimes Gummo. Here are the three main culprits in a replication of their roles in *Animal Crackers* (1930), in which the smart-alecky Groucho performs "Hooray for Captain Spaulding." Harpo played the harp, Chico the piano, and Groucho the jokes on everybody else.

Gene Kelly brought a new athleticism to dance on film in such successes as *Anchors Aweigh* (1945), *On the Town* (1949), and *An American in Paris* (1951). He brought a double take, here, to the Movieland Wax Museum as he stands in front of his likeness in the all-time classic musical *Singin' in the Rain* (1952).

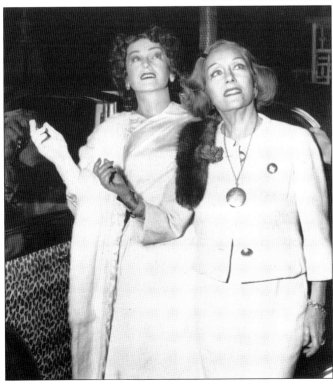

Joan Crawford and Bette Davis played rival film-star sisters in Robert Aldrich's *What Ever Happened to Baby Jane?* (1962), a histrionic melodrama.

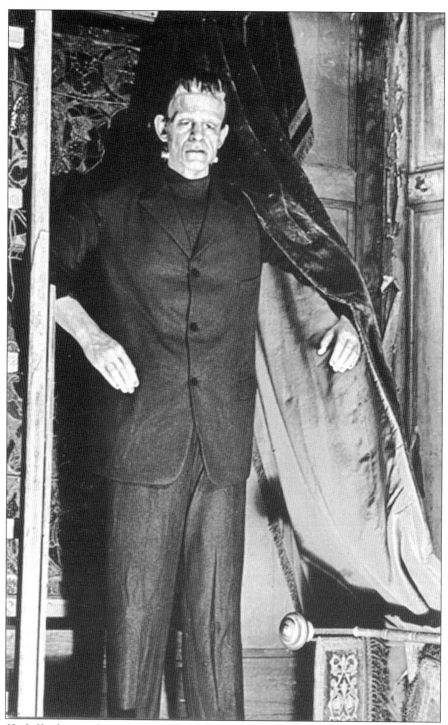

Boris Karloff, who was born William Henry Pratt, was best known for his roles in horror films and his portrayal of Frankenstein's monster in *Frankenstein* (1931). For his contributions to film and television, Karloff was awarded two stars on the legendary Hollywood Walk of Fame at 1737 Vine Street for motion pictures and 6664 Hollywood Boulevard for television work.

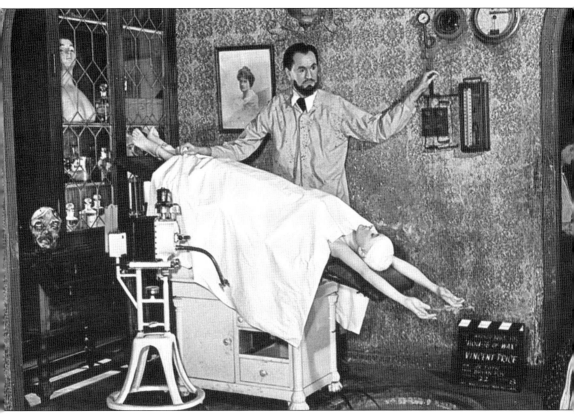

The Movieland Wax Museum probably wouldn't have been complete without a likeness of Vincent Price in *House of Wax* (1953). He played a revenge-minded sculptor who used humans to create wax figures. Any similarity between Price's diabolical activities and the museum's creative staff was purely coincidental. Charles Bronson played a supporting part. The Price film was remade in 2005 and itself was a remake of *Mystery of the Wax Museum* (1933) starring Lionel Atwill and Fay Wray.

In *The Poseidon Adventure*, a luxury ocean liner tips over at sea and the survivors climb up to the bottom of the ship, encountering many obstacles. Gene Hackman starred with Ernest Borgnine, Stella Stevens, and Shelley Winters.

The red carpets of Hollywood have attracted the greats, near-greats, and ingrates over the years. These two arrivals happen to be the principals of Billy Wilder's classic *Sunset Boulevard* (1950): Gloria Swanson as fading star Norma Desmond and William Holden as screenwriter Joe Gillis. The likeness of the chauffeur to the left of the stars was Erich von Stroheim, a great director in his own right.

Ben-Hur (1959), an epic film based on Lew Wallace's novel of the same, and starring Charlton Heston, was directed by William Wyler. The film, which costarred Jack Hawkins, Stephen Boyd, and Hugh Griffith, won 11 Academy Awards. Metro-Goldwyn-Mayer inherited the property when the company was founded in 1924.

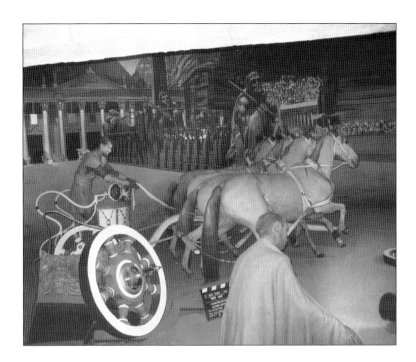

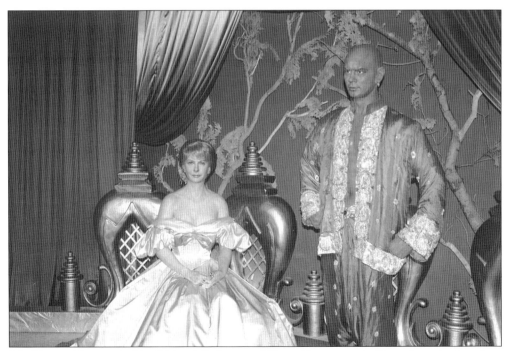

The King and I, a musical by Richard Rodgers and Oscar Hammerstein II, used a script based on the book *Anna and the King of Siam* by Margaret Landon. The plot comes from the story written by Anna Leonowens, who became a schoolteacher to the children of King Mongkut of Siam in the early 1860s. Yul Brynner and Deborah Kerr starred in the 1956 film version.

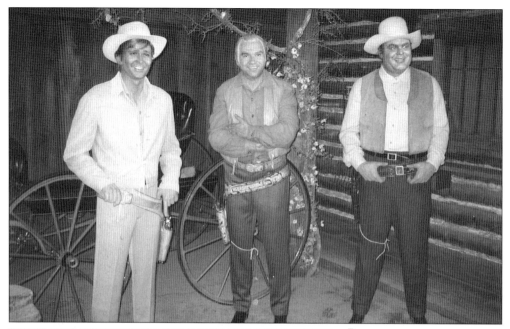

Bonanza was set near
Virginia City in the 1860s,
chronicling the adventures
of the Cartwright family
on the Ponderosa Ranch.
Bonanza aired on NBC for 14
seasons, becoming one of the
longest-running and popular
Westerns. Lorne Greene
starred as Ben Cartwright,
with Pernell Roberts, Dan
Blocker, and Michael Landon
as his sons.

In this Movieland Wax
Museum scene from the
silent classic *The Gold Rush*
(1925), Charlie Chaplin
inhabits his customary
Little Tramp role. Chaplin
wrote and directed the film.
Inside the cabin, hungry and
desperate, the Tramp and Big
Jim celebrate Thanksgiving
dinner in a famous
meal scene.

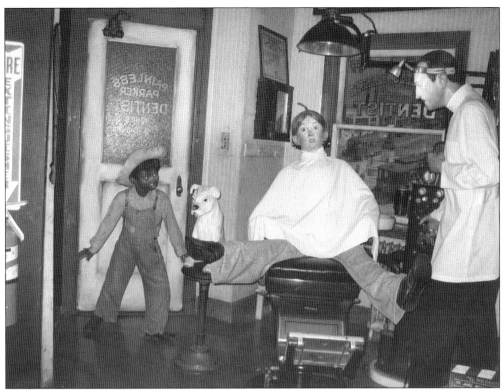

In this scene from *The Awful Tooth* (1938), the Our Gang regulars include, from left to right, Buckwheat, Pete the pup, and Alfalfa; to the right and not pictured are Darla and Spanky. They learn that the "good fairy" gives money for lost teeth. They get the idea to go to the dentist to have all of their teeth pulled so they can make plenty of cash to buy some sports equipment.

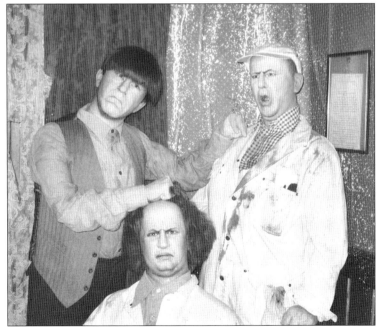

The Three Stooges started in 1925 as part of a Vaudeville act called Ted Healy and His Stooges. They were known by their first names: Moe, Larry, and Shemp, with Curly added in the later years. The Horwitz (later Howard) brothers involved were Harry Moses (Moe), Jerome (Curly), and Samuel (Shemp), along with longtime friend Larry Fine, who was born Louis Feinberg.

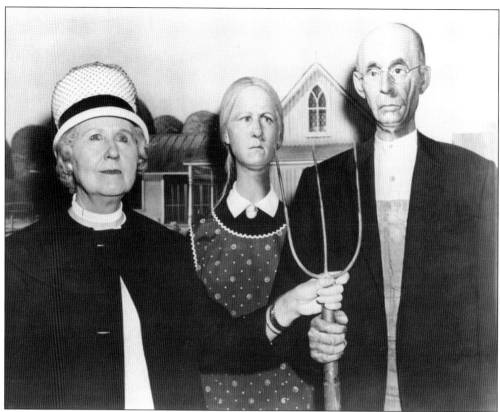

A million-dollar structure was added to the Movieland Wax Museum in 1966. This addition, "Palace of Living Art," presented replicas of great paintings alongside their exact reproductions in three-dimensional scenes created from wax sculpture, wardrobe, and dramatic display techniques. These replicas represented such paintings as *Mona Lisa*, *Blue Boy*, *American Gothic*, and Van Gogh's *Bedroom at Aries*. (Courtesy of Rodney Fong.)

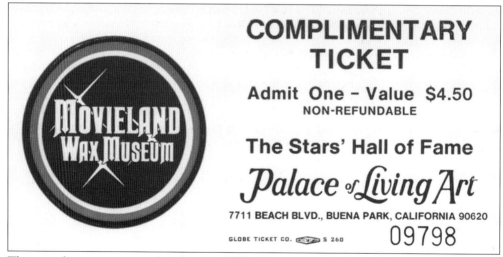

This complimentary pass to the Movieland Wax Museum was issued after the "Palace of Living Art" exhibit was installed.

Five

WILDLIFE ATTRACTIONS

This chapter groups together three attractions that showcased wildlife, all of them highlighting exotic fauna: California Alligator Farm in Buena Park; Japanese Village and Deer Park, which later evolved into Enchanted Village, also in Buena Park; and Lion Country Safari in Irvine.

In 1906 or 1908, Joseph "Alligator Joe" Campbell and Francis Victor Earnest Sr. relocated an alligator farm in Hot Springs, Arkansas, to a Los Angeles location adjacent to the Selig Zoo and Motion Picture Studio in Los Angeles. This Alligator Farm rented reptiles to the motion picture industry. The farm moved to Buena Park in Orange County in May 1953 and continued to operate as California Alligator Farm until 1983, when its lease was not renewed. Four buildings on the farm contained more than 100 displays of snakes and lizards from throughout the world. The farm contained snapping turtles, giant tortoises, and more than 1,000 specimens in what was called the largest reptile collection in the world.

Allen Parkinson's Movieland Wax Museum near Knott's Berry Farm became a popular destination, and he planned another attraction just 100 yards from the Santa Ana Freeway at the Knott Avenue turnoff. This 32-acre site was developed in 1967 into Japanese Village, billed as the largest Japanese cultural and recreational center in the Western Hemisphere and the first and only deer park in America. The design was originally inspired by a deer park located in Nara, Japan. The enterprise went bankrupt and closed, then reopened with somewhat of a new theme and the new title of Enchanted Village. Parkinson kept the park until 1970, when he sold it to Newport Beach–based Recreation Environments, Inc. Eventually Six Flags Corporation bought the park.

Lion Country Safari opened on 140 acres of Irvine Ranch in 1970. Visitors stayed in their cars and drove among free-ranging lions, giraffes, and hippopotami. The park drew more than one million customers a year. An unlikely star attraction was an aging, nearly toothless lion named Frasier, a Mexican circus veteran that arrived in February 1971. The cat's tongue dangled from one side of his mouth, and he had trouble walking. The lionesses were not put off. Lion Country Safari was originally developed by a group of South African and British entrepreneurs who wanted to bring the experience of an African game park to the United States. Later, rides, shows, and a petting zoo boosted attendance. The park closed in 1984.

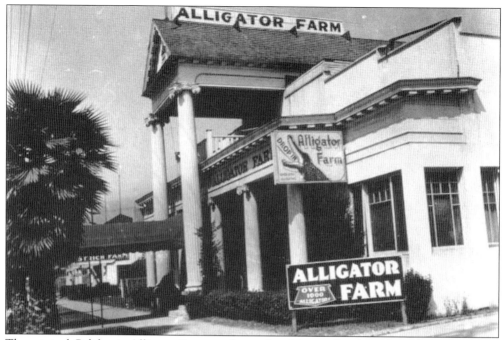

The original California Alligator Farm was located on Mission Road and Lincoln Park Avenue in Los Angeles. (Courtesy of Ken and Sharon Earnest.)

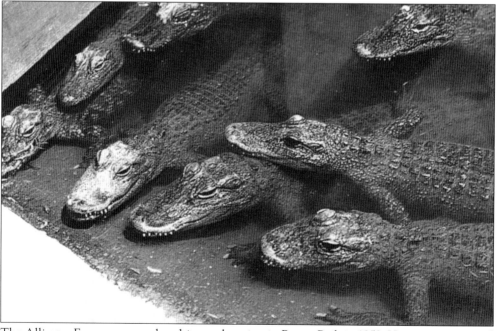

The Alligator Farm was moved to this new location in Buena Park in 1953. Here it was renamed the California Alligator Farm. The 2-acre park was located at 7671 La Palma Avenue. This location proved to be a popular attraction for three decades, drawing up to 130,000 a year at its peak. (Courtesy of Ken and Sharon Earnest.)

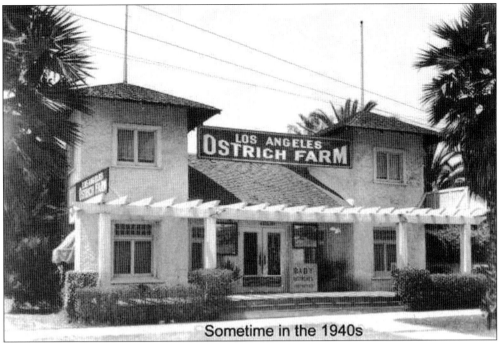

Sometime in the 1940s

The California Alligator Farm was one of the oldest zoological attractions in the state of California, along with Cawston's Ostrich Farm in South Pasadena. The Alligator Farm supplied alligators to hundreds of motion pictures. Visitors to the Buena Park Alligator Farm included Albert Einstein, Lucille Ball, Michael Landon, Anthony Perkins, and television's *Rifleman*, Chuck Connors. (Courtesy of Ken and Sharon Earnest.)

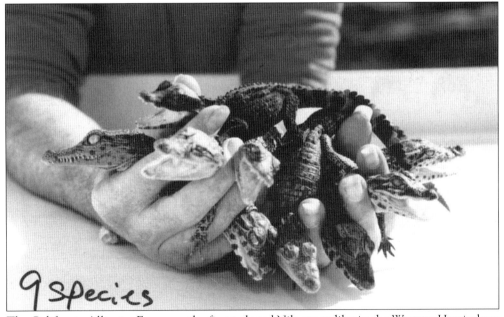

The California Alligator Farm was the first to breed Nile crocodiles in the Western Hemisphere and the first to breed Mugger crocodiles, Cuban crocodiles, and Ceylonese pythons. (Courtesy of Ken and Sharon Earnest.)

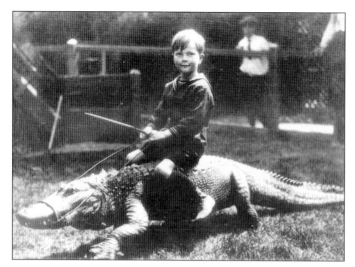

Pictured here is Billy the alligator with young Francis Victor Earnest Jr. Billy became a kind of star in his own right. He had a beautiful smile and posed as nearly all the large alligator jaws seen on movie screens around the world. Directors were fond of the reliable reptile because his jaws automatically opened when a chunk of meat dangled above his head—just above the camera's field of vision. (Courtesy of Ken and Sharon Earnest.)

The California Alligator Farm was a herpetologist's heaven. At its peak, it was home to more than 500 alligators and crocodiles and 500 snakes. The Alligator Farm was beset by dwindling attendance in the 1980s. Its animals were moved to a private preserve in Florida after a dangerous five-day rodeo: catching alligators, crocodiles, and caimans. They were flown by a 707 to a private estate in Florida. Arthur Jones, the inventor of Nautilus sports equipment, became their host. (Courtesy of Ken and Sharon Earnest.)

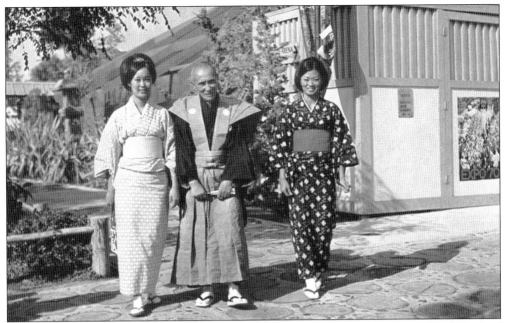

This is a postcard welcoming visitors to the Japanese Village and Deer Park. With a flourish of colorful Shinto rites of purification, one of Orange County's most unusual amusement parks was dedicated on June 15, 1967. For the next seven and a half years, Japanese Village and Deer Park would grace the corner of Knott Avenue and Artesia Boulevard in Buena Park with an odd combination of Asian serenity and animal showmanship.

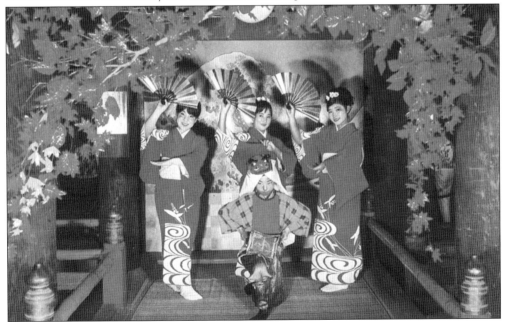

Japanese Village was considered the largest Japanese cultural and recreational center in the Western Hemisphere. The design of Japanese Village and Deer Park was originally inspired by a deer park located in Nara, Japan. Japanese Village and Deer Park was the first and only deer park in America. Here Japanese fan dancers perform.

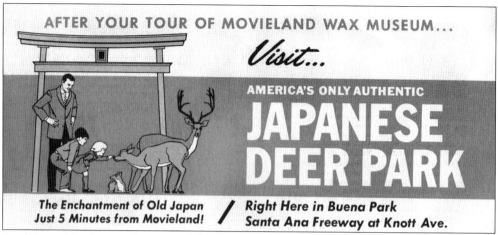

As this graphic element illustrates, Allen Parkinson cross-promoted both of his attractions. On the front side, he publicized his Japanese Village and Deer Park, and on the reverse side it was Movieland Wax Museum.

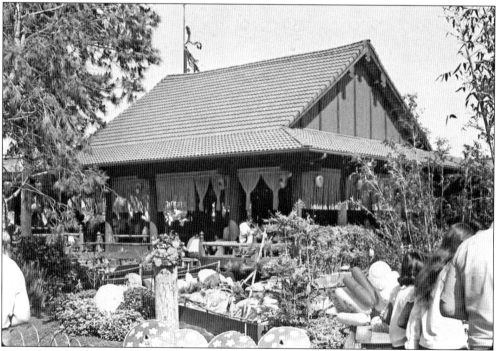

Japanese Village was landscaped in a traditional Japanese method with serene Koto music floating through hidden speakers and bamboo rustling in the breeze as visitors proceeded down the landscaped walks.

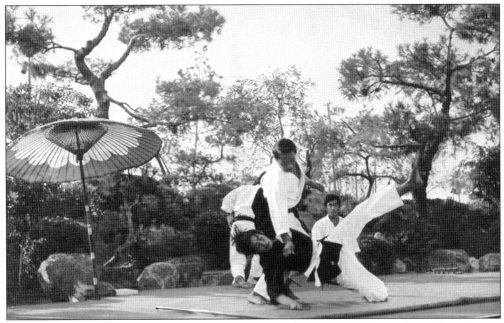

Japanese Village hosted a myriad of animal shows. It had an open-air stadium where karate experts would demonstrate a form of self-defense and break pieces of wood with their bare hands and feet.

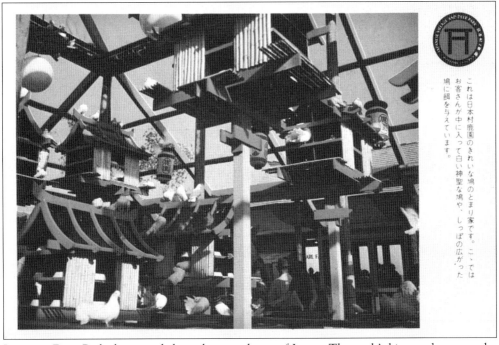

これは日本村鹿園のきれいな鳩のとまり家です。ここでは
お客さんが中に入って白い神聖な鳩や、しっぽの広がった
鳩に餌を与えています。

Japanese Deer Park showcased the culture and arts of Japan. The park's biggest draw was the deer, but there were other draws as well, including koi ponds, Japanese gardens, and a dove aviary, seen in this postcard.

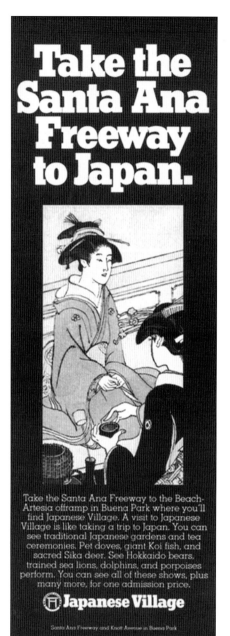

Take the Santa Ana Freeway to Japan.

Take the Santa Ana Freeway to the Beach-Artesia offramp in Buena Park where you'll find Japanese Village. A visit to Japanese Village is like taking a trip to Japan. You can see traditional Japanese gardens and tea ceremonies. Pet doves, giant Koi fish, and sacred Sika deer. See Hokkaido bears, trained sea lions, dolphins, and porpoises perform. You can see all of these shows, plus many more, for one admission price.

🚪 Japanese Village

Santa Ana Freeway and Knott Avenue in Buena Park

The Japanese Village and Deer Park had lush green gardens, and Japanese architecture could be found throughout the park. In those days, the advertising led a person to believe that the Santa Ana Freeway could eliminate crossing the Pacific.

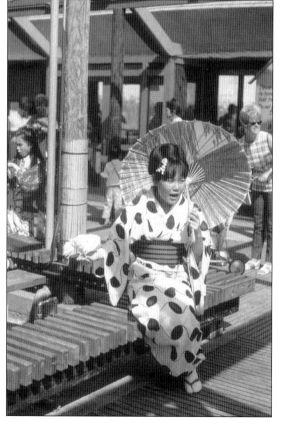

This image shows one of the Deer Park employees feeding a dove. At one time, one of the popular attractions at the park was an act featuring Hokkaido bears that threw basketballs through hoops. The park also had performing dolphins, karate exhibitions, Kabuki dancing, and pearl diving.

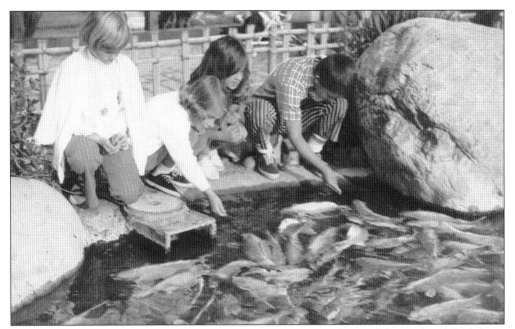

Visitors could purchase specially prepared food for yellow carp, koi, and deer to hand-feed them. Vending machines dispensed seal, carp, and dove food, which provided incentive for the white birds to perch on patrons' hands.

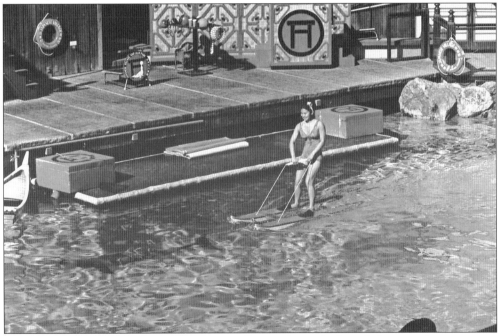

Here is a dolphin and trainer at the Japanese Village and Deer Park, with the waterskiing courtesy of dolphin power. Baby bottles could be rented to feed a bear cub at the park, and the deer would often nibble at clothing. Most deer at Japanese Village and Deer Park were sika deer, which are found in several regions in East Asia and are native to Japan. Other species of deer at the park were English fallow deer and Indian axis deer.

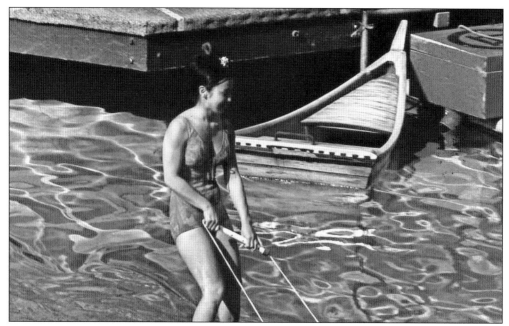

The park featured several pavilions that provided more lively forms of entertainment, like "dolphin skiing" or Hokkaido bears, which would ride teeter-totters and walk high-wires.

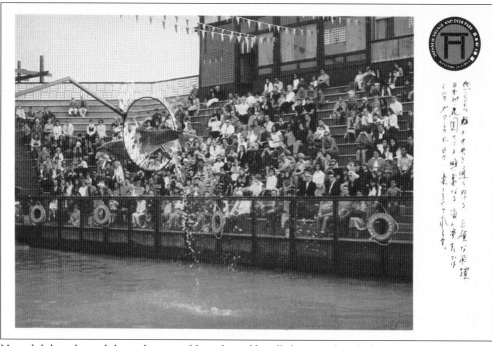

Here dolphins leaped through rings of fire, cleared hurdle bars, and took their trainer for bareback rides. A special filtering system added salt and other compounds to the water, creating a balance like that of the Pacific Ocean, right down to the temperature. The water was checked daily to ensure correct metering.

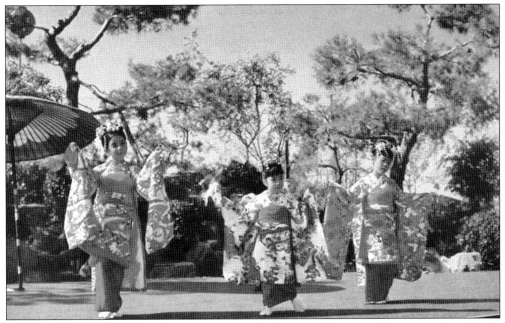

These Kimono-clad girls are shown in costume for dance exhibitions. Always popular with the thousands who would visit the spacious Buena Park entertainment complex each week were the graceful Japanese dancing exhibitions.

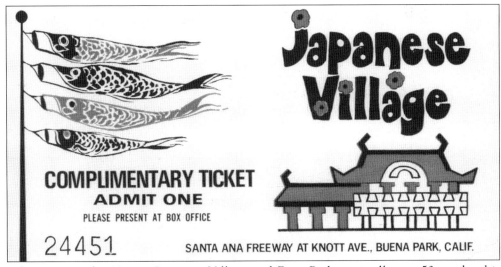

Admission to the 32-acre Japanese Village and Deer Park originally was 50¢ or by this complimentary pass.

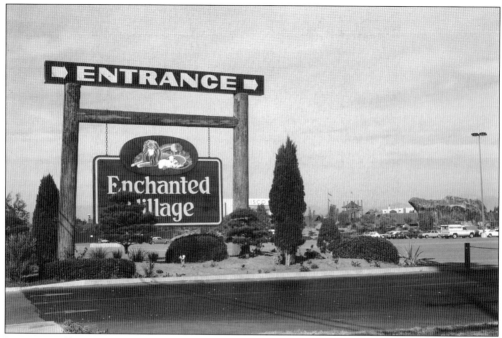

Japanese Village and Deer Park was renamed Enchanted Village in 1976 and billed as an exotic-animal reserve. It used methods of training animals that emphasized familiarity, petting, and mutual trust. (Courtesy of Rick Bastrup.)

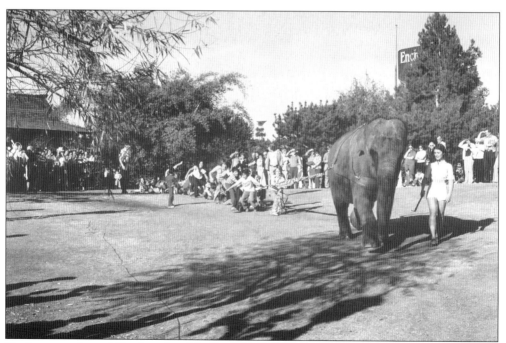

Elephants performed "lie down" and "roll over" in giant exhibitions of dog tricks. Chimpanzees folded their hands behind their backs and strolled the park like worried executives. (Courtesy of Rick Bastrup.)

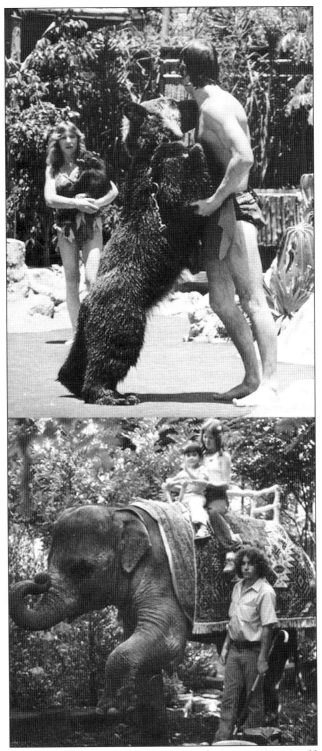

Enchanted Village retained at least one gentle Hokkaido bear, a species of brown bear from northern Japan (above). The elephants (below) were from Asia.

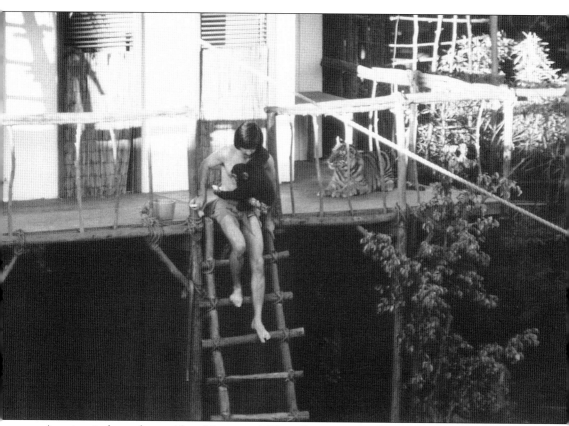

A trainer is shown here with a chimpanzee. The village contained more than 600 exotic animals trained through Ralph Heifer's "affection training" concept. The park changed from a quiet place with petting zoos and koi ponds to more of a themed amusement park with a tiger arena, Tokyo Car Ride, shooting gallery, and the Pearl Lagoon Theatre.

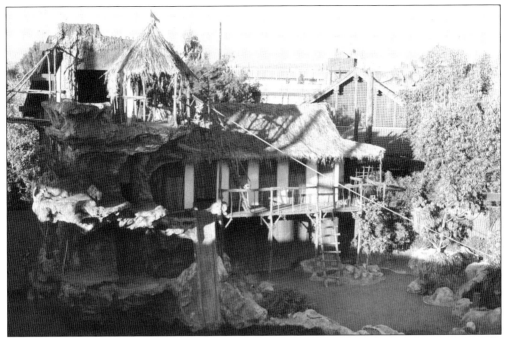

This was a typical jungle-styled setting at Enchanted Village. Ralph Heifer was the originator of a new training method for wildlife that emphasized patience and understanding. He familiarized the animals with human touch and then advanced to petting before moving on to training. Heifer's methods were used on the 1960s television series *Daktari* with Marshall Thompson and *Cowboy in Africa* with Chuck Connors. (Courtesy of Rick Bastrup.)

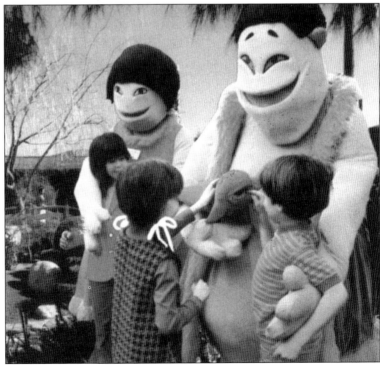

Enchanted Village employed costumed characters called Fuji Folk, who are seen here. (Courtesy of Rick Bastrup.)

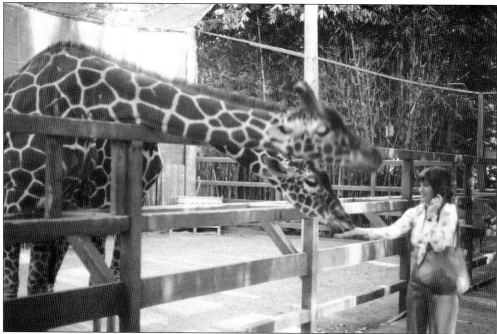

The animals often fed out of the hands of trainers as well as guests. This woman is feeding two giraffes that are native to East Africa. (Courtesy of Rick Bastrup.)

After more than a year of financial troubles, Enchanted Village closed in 1977. Heifer was unable to obtain all the loans that he been promised from various savings-and-loan corporations. Heifer, who was chairman of the board of directors of Enchanted Village, had assets of $6.9 million but little cash. The major assets of Enchanted Village were the 32 acres it sat on. Enchanted Village, which contained scenic waterways like this one, was only open for business for one year. (Courtesy of Rick Bastrup.)

The 140-acre Lion Country Safari, which contained 800 birds and animals from Africa, was located an hour each from Los Angeles and San Diego and a 20-minute drive from Disneyland. Convertibles were not allowed on the safari. They had to be parked at the Hertz Hut, where an air-conditioned vehicle could be rented. Pets weren't permitted in automobiles touring the preserve. They had to be checked at the Kal Kan Kennel Club for free. This is the Lion Country Safari entrance.

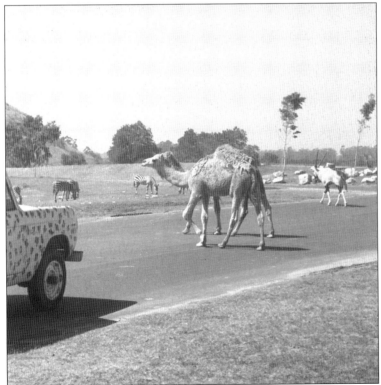

The animals would always have the right-of-way at the park. Windows had to be rolled up at all times. Photography was only allowed through the windshield or other car windows. Eight miles of paved trails allowed drivers and families to view animals in the open instead of behind conventional zoo bars. Lion Country Safari contained 24 cheetahs, 20 elephants, and 53 zebras. Patrons drove among antelope, hippopotami, deer, and lions.

The Southern California temperatures weren't quite as warm as equatorial Africa, but the balmy environment suited the transplanted critters well. The well-fed lions roamed peacefully about, and usually the only surprise drivers might encounter was the ostriches' penchant for pecking at car windows.

The reserve, located in the city of Irvine, had the Afri-Theatre (a 350-seat theater of jungle design), free-flight aviary, reptile exhibit, and nurseries for elephants and chimps. After the tour, visitors could leave their cars at the Safari Camp and the Entertainment Area. The Zambezi River Cruise was available at 75¢ for adults and 50¢ for children. Thirty-six-foot boats cruised past and among live hippos.

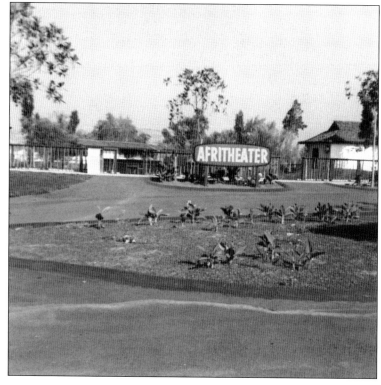

120

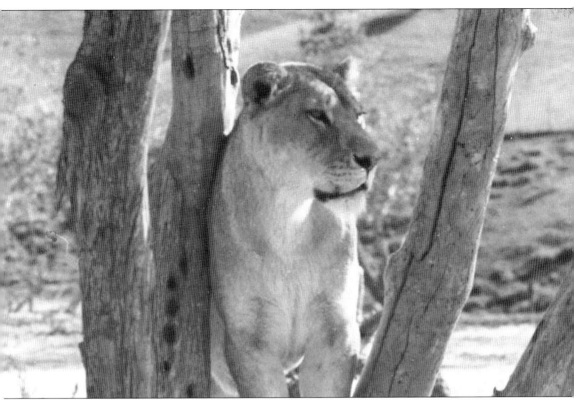

Frasier, the old lion from a Mexican circus, had a pride of seven lionesses and fathered 35 cubs in two years. He was a refugee from the circus when he was bought for Lion Country Safari. Frasier earned some notoriety in the press when he received a nomination in a nationally operated civic contest as 1972's Father of the Year.

Lion Country Safari was built at a cost of $11.5 million. During its first year in operation, attendance was 1.2 million. The first Lion Country Safari venture was in West Palm Beach, Florida, built in 1967. The park in Florida received national acclaim as an authentic game preserve. Here the huts are, for the most part, dissembled.

Admission to the game reserve was $3.25 for adults and $1.50 for children under the age of 11. Cassettes provided a tape-recorded narration of the tour for $1. Pictured is a complimentary pass to the park. The Lion Country Safari closed in 1984.

Six

OLD MACDONALD'S FARM

Walter Knott had been on the lookout for an old-style farm attraction to supplement the overall operations at Knott's Berry Farm. Fulton Shaw created Old MacDonald's Farm in 1954 for the Knott family as an independent operator.

Old MacDonald's Farm opened at Knott's Berry Farm near the old seal pool in January 1955. Fulton's operation of the attraction was shared with his wife, Kay, who worked for Walter Knott in the Bird Cage Theatre.

The Shaws left Knott's Berry Farm in early 1969 after 15 years of Old MacDonald's notoriety at Knott's. In the summer of that year, the early residents of the future city of Mission Viejo acquired a whole new concept of old-time farming with the arrival of the new Old MacDonald's Farm, 7 acres off Interstate 5 and Crown Valley Parkway. When Fulton moved his farm down to Mission Viejo, it was the only amusement park in south Orange County.

Old MacDonald's Farm at both locations was primarily designed for children and featured a mule-powered merry-go-round. But it catered to all ages with the look of a working storybook farm and featured an old-fashioned country store with accoutrements representing the 1880s.

The store featured authentic antique oak display cases filled with candies and barrels of gift-styled goods. A tram whisked people from the present to the past in the realm of the Old MacDonald's Farm environment. Roaming around were chickens, geese, ducks, and piglets. The Blacksmith's Shop was a favorite stop.

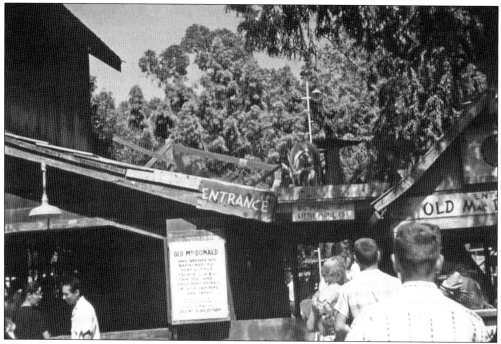

At Knott's Berry Farm, the barnyard animals would react to the sound of automatic feeders. They would eat constantly, so they had to be rotated every 45 minutes with another one of their kind. Here is the entrance to the farm.

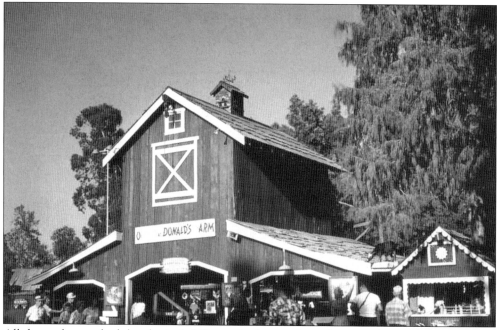

All the performers had the physical ability to do their tricks without much trouble. Methuselah, the goat, would butt for his oats and grain pellets. Chicken Little's kin pulled a dinner bell for snacks. Porky Pig slid himself to a treat. Peter Cottontail hopped onto a cable car and nibbled alfalfa pellets at the end of the line.

Fulton Shaw had a long-standing relationship with Knott's Berry Farm before moving his business to Mission Viejo. Old MacDonald's Farm reopened there in August 1969.

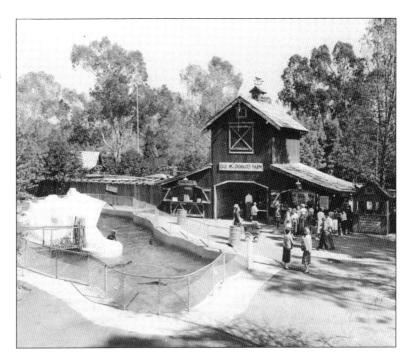

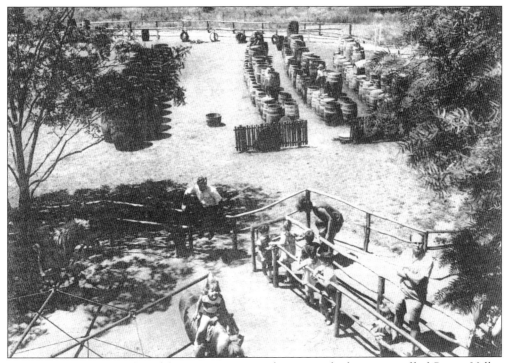

Old MacDonald's Farm lasted four years at its new location, which was just off of Crown Valley Parkway and Interstate 5. Fulton relocated Old MacDonald's Farm after a disagreement with the Knott family. The farm featured a mule-powered merry-go-round. (Courtesy of the Mission Viejo Heritage Committee.)

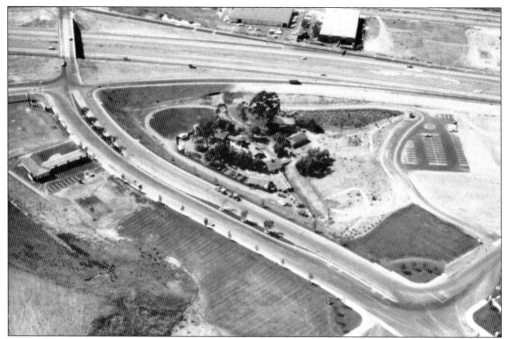

In 1969, residents of the area that became the city of Mission Viejo acquired a whole new concept of farming with the arrival of Old MacDonald's Farm, with 7 acres of farm-style attractions brought in. When Fulton Shaw moved Old McDonald's Farm from Knott's Berry Farm, it was then located off the I-5 Freeway and Oso Parkway. (Courtesy of the Mission Viejo Heritage Committee.)

When Fulton Shaw moved his farm down to Mission Viejo, it was the only amusement park in the south end of Orange County. The place was a homey world of fun and farm life for the visitors to enjoy. (Courtesy of the Mission Viejo Heritage Committee.)

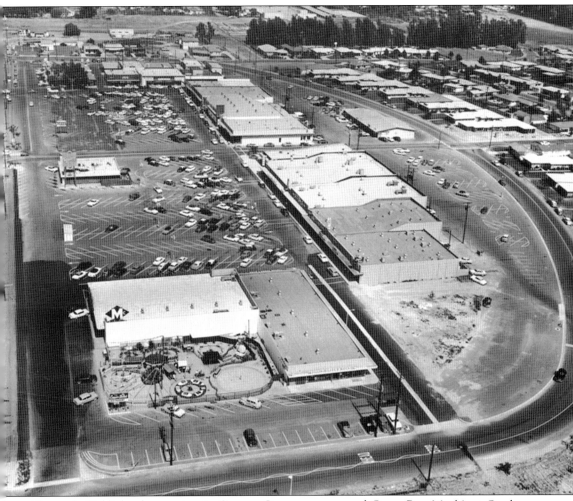

The only Kiddieland operating in Orange County was named Gram Paw Mack's at Garden Grove Boulevard and Belfast Avenue. It sat on an acre, a dirt lot in a shopping center. It operated from about the mid-1950s to the early 1970s. Kiddielands took advantage of the postwar baby boom and catered to children ages 10 and under. The evolution of Kiddielands was based on traditional amusement parks. They operated perhaps a few circle rides—cars, boats, a miniature train, a carousel, pony rides—and possibly a small Ferris wheel. Some had picnic grounds. The Allan Herschell Company of North Tonawanda, New York, which significantly developed the amusement-ride industry, also built scaled-down rides for the Kiddielands. The phenomena of Kiddielands has disappeared entirely, usurped by climbing features at fast-food restaurants or in malls and other more upscale developments, such as kids' museums and well-equipped day-care centers. People who fondly recall Kiddielands often can't really remember where they were. (Courtesy of the Orange County Archives.)

ACROSS AMERICA, PEOPLE ARE DISCOVERING
SOMETHING WONDERFUL. *THEIR HERITAGE.*

Arcadia Publishing is the leading local history publisher in the United States. With more than 4,000 titles in print and hundreds of new titles released every year, Arcadia has extensive specialized experience chronicling the history of communities and celebrating America's hidden stories, bringing to life the people, places, and events from the past. To discover the history of other communities across the nation, please visit:

www.arcadiapublishing.com

Customized search tools allow you to find regional history books about the town where you grew up, the cities where your friends and family live, the town where your parents met, or even that retirement spot you've been dreaming about.